The Green Man in Britain

Fran & Geoff Doel

The
History
Press

Dedication: In appreciation of our parents —
Tom and Isabel Gilmour, and Sidney and Olive Doel

First published in 2001 by Tempus Publishing
Reprinted 2004

Reprinted in 2010 by
The History Press
The Mill, Brimscombe Port,
Stroud, Gloucestershire, GL5 2QG
www.thehistorypress.co.uk

Reprinted 2012

British Library Cataloguing in Publication Data.
A catalogue record for this book is available from the British Library.

ISBN 978 0 7524 1916 9

Typesetting and origination by Tempus Publishing Limited.
Printed and bound in Great Britain.

Contents

List of illustrations

Acknowledgements

We would particularly like to thank our photographer Felicity Howlett for providing most of the photographs of cathedral and church carvings. We would also like to thank the organising bodies of cathedrals and churches for allowing the photographs to be taken and for their use in this book. Our thanks go to Davyd Power for providing the illustration of the Green Man in Tonbridge Church, for Peter Kemmis Betty for providing the illustration of Pennant Mellangel Church Screen, to Archie Turnbull for the photograph of the Hastings Jack in the Green, and to Stuart Beattie for sending us a photo and a carving of Green Men in Rosslyn Chapel. Our thanks also go to the photographer Antonio Reeve and the Rosslyn Chapel Trust for permission to use the photograph on the front cover and in the book. With grateful thanks to Liz Johnston, Assistant Custodian, St Magnus Cathedral, Orkney for sending us a photograph of a Green Man head from St Magnus, a map of the locations of other Green Men in the cathedral, an original sketch of a Green Man in the cathedral and a photo of an antique chair kept in the cathedral which has a Green Man carving on its back, and for permission to use them in the book. Most of the modern photographs of the folk customs, and some of the Green Men carvings, were taken by the authors.

We would like to thank the large number of people who have helped us with information on ecclesiastical carvings, including priests, curates, churchwardens, cathedral guides and students and friends who over the years have most helpfully supplied us with information. Regretfully, it is not possible to list all of these individuals, but we are most grateful for their kind and invaluable assistance and fruitful discussions. However, we would particularly like to thank the following: Alan Austen, Brenda Bamford, Rev Paul Botting, Fr Dominic Dougan, Deborah Hutchinson, Keith Leech, Alan and Renella Philips, Alan and Judy Schneider, Margaret Slater, Rev Philip and Valerie Tait and Archie Turnbull.

We should also like to thank Keith Leech for information on the Hastings Jack in the Green Folk Custom and its revival, Gordon Newton for information of the revival of the Rochester revival, and George Bramhall for help and information over many years when we have taken groups to see the Castleton Garland celebrations.

We would also like to acknowledge the help and interchange of ideas with fellow lecturers with whom we have shared courses on the Green Man and associated folk customs, particularly William Tyler, Mike Spittal, Alan Austen and Tom Brown. We have been particularly indebted to books on the subject by C.J.P. Cave, Kathleen Basford, William Anderson and Clive Hicks, and amongst the many local books we have consulted we have particularly drawn on Thirlie Grundy's *The Green Man in Cumbria* as we have not so far been able to personally visit all of the Cumbrian sites.

Introduction

A range of articles and books from the 1930s to the present have explored the significance of foliate disgorging heads in ecclesiastical carvings and whether they might be associated with Christian symbolism and/or to a wider range if images from traditional culture, such as folk customs and legends. As we show in the opening chapter of this book, the term 'Green Man', both as name for the disgorging foliate heads in ecclesiastical carvings and as the name for a more broadly based symbolic or quasi-mythical figure whose aspects were celebrated in literature, legends and customs, as well as being carved in cathedrals and churches came increasingly to be used in the latter part of the twentieth century.

One avenue of scholarly inquiry, which traced the influence of the genre largely from Roman carvings in Temples of Bacchus through to carvings in French churches and from there into England, Wales and Scotland, reached its climax in the acclaimed book *The Green Man* by Kathleen Basford, which was published in 1978, just as we were beginning our lecturing careers.

The second avenue of inquiry, which was to try to connect the ecclesiastical carvings with other aspects of culture, including the environmental concerns of the late twentieth century, was cogently and excitingly explored by William Anderson in his influential *Green Man — The Archetype of our Oneness with the Earth*, published in 1990. William Anderson was a European, a man of wide cultural knowledge, and to interpret his wider vision of the Green Man, he enlisted the aid of two cultural gurus from the early twentieth century — the anthropologist Sir James Frazer and the psychologist Jung. Whereas Jungian archetypal studies were all the rage in the period Anderson was researching his book, his use of Sir James Frazer was singularly daring, as Frazer's anthropological vision was (and still is) suffering a remarkable eclipse in anthropological and folklore circles. There was bound to be a reaction against the uncritical admiration of earlier generations for Sir James and his vision of comparative interrelated mythology and rituals, particularly when modern scholarship got to work on his sources, but the extreme hostility to what some academics now term 'The Golden Bow-Wow' has always surprised us in its uncompromising intensity. It was of course one of William Anderson's great virtues that he was able to stand clear of scholarly in-fighting and trends in his quest for truth.

William Anderson's book had a great influence on us in that it gave a focal point and coherence to many topics we were exploring individually. We were both teaching the increasingly popular medieval text *Sir Gawain and the Green Knight* on literary syllabi and summer schools; we were researching traditional customs and organising educational courses and visits to customs such as the Jack in the Green at nearby Hastings and Rochester, the Castleton Garland, the Burry Man, the Padstow Hobby Horse and the Helston Flora; and we were running a local Mummers team which featured both Midwinter and Robin Hood Plays. We began to group these topics together under a 'Green Man' title for adult education courses and Summer Schools for the Universities of Kent, Exeter, East Anglia and Birkbeck College in order to explore possible interconnections with our students. In the past decade we have been involved in countless fascinating debates with fellow lecturers, students and other friends as to the precise significance of both the medieval Green Man (if indeed there was one) and what he stands for today and the reason for the extraordinary interest in him at the present time. Some of our feminist students argued that there must be a green woman as well; other people wondered why the images were male. And the fundamental debate as to whether the ecclesiastical carvings were related to figures in folk customs and legends, or whether his significance was entirely Christian (his present significance is clearly more than Christian) continues.

And so we have written this book:

(i) to provide a history of the development of the term and concept of the Green Man and what it has come to signify today

(ii) to explore the significance of the Christian carvings

(iii) to provide information on the wider cultural associations claimed for the Green Man in literature, folk customs and legends

(iv) to provide a large collection of photographs of ecclesiastical carvings and associated folk customs

(v) to provide a selective and accurate gazetteer of Green Man ecclesiastical sites for readers to visit

Photographing church carvings is a very skilled task. Only a few of our hundreds of Green Men photos are of a good enough standard for publication, so we have been very fortunate to acquire help from a skilled photographer, Felicity Howlett, who has provided most of the ecclesiastical photographs for the book as well as alerting us to several Green Man carvings

we were unaware of. Our own photography is hopefully adequate for the folk customs we have visited and described in the book. For further information on the customs we would refer readers to Brian Day's *A Chronicle of Folk Customs*.

We hope that our book will encourage readers to form their own opinions based on the evidence provided. Information is provided on the iconography and locations of the ecclesiastical heads disgorging vegetation, and on the folk customs and legendary and literary figures that many scholars have associated with him, and there is also a summary of previous interpretations of the significance of the figure. We have tried to retain open minds on the subject whilst writing the book, but our own tentative conclusions are given in the concluding chapter. We hope that the reader's quest for the Green Man will be as enjoyable and illuminating as ours has been.

Fran & Geoff Doel
Owl House, Tonbridge

1 The Green Man — invention or recreation?

In 1932 C.J.P. Cave published an article 'The Roof Bosses of Ely Cathedral', which compared foliate head carvings on those bosses to the Jack in the Green, a man appearing in May Day ceremonies in the south of England covered in a wooden frame filled with greenery:

> It would be interesting to know the meaning of these heads . . . Those cases where the face is hidden except for the eyes . . . remind me of the Jack-in-the-Green.

In 1939 Lady Raglan published an article in the 1939 Folklore Journal on the subject of 'The Green Man in Church Architecture'. This suggested a connection between a foliate head church carving in Llangwm Church in Monmouthshire and figures of folklore, custom and legend:

> It seemed to me certain that it was a man and not a spirit, and moreover that it was a 'Green man'. So I named it. . . . This figure is neither a figment of the imagination nor a symbol, but is taken from real life, and the question is whether there was any figure in real life from which it could have been taken. The answer, I think, is that there is only one of sufficient importance, the figure variously known as the Green Man, Jack in the Green, Robin Hood, The King of May, and the Garland, who is the central figure in the May-Day celebrations throughout Northern and Central Europe.

This article appears to be the birth of the popular modern usage of the term in regard to church carvings and green clad figures in folklore and custom.

In his 1948 book *Roof Bosses in Medieval Churches*, C.J.P. Cave again drew attention to possible links between some of the carvings and 'the Jack-in-the Green which was a familiar figure on May Day in England fifty years ago'. He acknowledges that 'Quite independently Lady Raglan came to the same

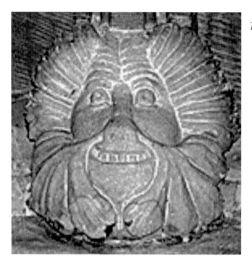

1 *Cheshire, St Mary, Nantwich. Fourteenth-century sandstone boss. Grinning human head sprouting branches and leaves from a nose which is itself a stylised representation of a tree. The furrows of the brow are also a simplified tree and the hair is vegetative.* Felicity Howlett

2 *Cheshire, St Mary, Nantwich. Fourteenth-century sandstone boss head. The nose and furrows of the brow and eyebrows form a tree. Foliage sprouts from the mouth and the beard may be a curling leaf.* Felicity Howlett

3 *Derbyshire, All Saints, Bakewell. Stone carving on apex of arch. Wide branches force their way into a grimacing mouth.* Felicity Howlett

4 *Devon, Exeter Cathedral. Late thirteenth-century roof boss in the ambulatory outside the Lady Chapel depicting two wide-eyed Green Men on the one boss. Their mouths disgorge luxuriant stemmed foliage which encapsulates the pair in a circle of greenery. Anderson identifies the greenery as artemisia (wormwood).*
Felicity Howlett

conclusion as to the origin of what she calls "the Green Man'" (p68). The coinage of the concept and terminology of the Green Man by Cave and Basford was quickly adopted by the establishment and ratified by its adoption in descriptions of carvings in Pevsner's architectural works, including the famous and highly influential 'Buildings of England' series.

German culture has a term, 'der gruner Mensch', which refers to figures in folk customs covered with greenery. The French equivalent, 'l'homme vert', seems to be more recent than Lady Raglan's coinage. The term 'Green Man' has become a convenient cultural shorthand to describe the most prolific non-Christian symbol to be found carved in or on British medieval religious buildings and their counterparts in parts of France and Germany. So widespread is this symbol that there may be a Christian significance. Useful as the term 'Green Man' has become, the widespread use of heads in association with foliage has meant that no two writers mean specifically the same thing by the term. In this book we will broadly take the term as meaning that there is a head disgorging vegetation from eyes,

nostrils, ears or forehead, or a foliate head where the cheeks are depicted as leaf-like.

In England the term 'Green Man' is also associated with hundreds of pub names, some dating back as early as the sixteenth century. But the evidence that has so far come to light as regards early inn signs suggests a virtually exclusive use of depictions of a forester, originally Robin Hood or some other outlaw, although many of the pubs have switched to wild Green Men type pub signs in recent years to fit in with modern perceptions.

The two outstanding modern studies in book form on the subject — Kathleen Basford's *The Green Man* and William Anderson's *Green Man — The Archetype of our Oneness with the Earth* represent two distinct approaches to the subject. Kathleen Basford's book is a study of one of the 'fantastic images' which abound in 'the medieval churches and cathedrals of Western Europe' — 'the foliate head, a face or mask with leaves sprouting from it'. Basford sees the Green Man as 'probably the most common decorative motif of medieval sculpture' and points out that the Jack in the Green does share one characteristic with the Green Man — 'his power of revival and regeneration'. In her study, however, she considers that the origins of the Green Man are artistic, deriving from the Roman art of the first century AD, in religious memorials associated with the gods Okeanus and Bacchus, using carvings of acanthus and vine leaves.

In support of Kathleen Basford's ideas is the rarity of Green Man carvings on secular sites. She finds the carvings in the medieval English churches sinister rather than life-evoking, symbolising the 'horrors of the silva daemonium' rather than the 'personification of Springtime'. However, there is an inconsistency in her thesis which on the one hand stresses the links with antiquity and on the other interprets the iconography as diabolical; Dionysus, Bacchus and Okeanus are not diabolical figures and do not attract diabolic iconography.

There is also a limitation in Basford's assumption that quizzical or unsettling expressions given to Green Man carvings by medieval masons and stone-carvers are expressions of Christian devils. Although the carvers are of course likely to be orthodox Christians, they could still possibly be portraying something that is neither a classical copy, nor something from the confines of Christianity; in some cases where vines and grapes are associated with the image, inebriation (whether or not related to Bacchus) may be depicted. The power of the recurring symbol of the Green Man in the thirteenth, fourteenth and fifteenth centuries may also relate to figures from the shadowy region of folklore and legend. Thus, while acknowledging the obvious mutual influence of the carvers in reproducing a striking and effective symbol, we may need to look wider than Christian thought and iconography to interpret the Green Man's full significance. It is this wider quest that is much indebted to William Anderson's book.

5 *Devon, Exeter
Cathedral. Painted roof
boss in south aisle. The
nose is a tree which
branches into spreading
oak leaves from the tear
ducts and the nostrils.*
Felicity Howlett

6 *Devon, Exeter
Cathedral, Exeter.
Tripartite representation
on the corbel in nave.
The Coronation of the
Virgin, the Virgin and
child as* radix jesse
*standing on a Green
Man c.1350.* Geoff
Doel

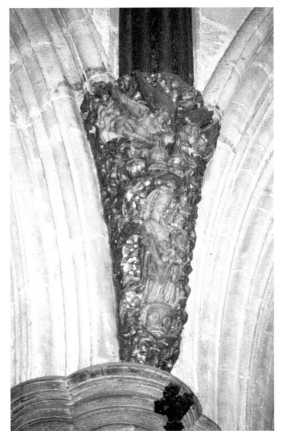

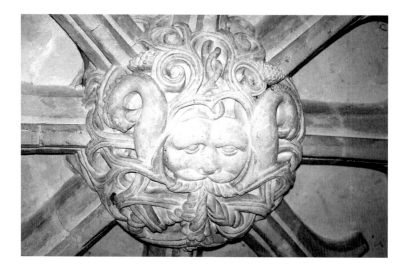

7 *Devon, Ottery St Mary. Fourteenth-century roof boss above the current interior*
 church shop. Head spews forth thick branches of greenery which form an
 'inhabited' bush with backward facing biting birds and grape clusters or cones.
 Felicity Howlett

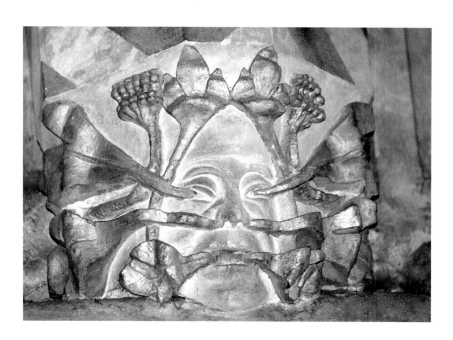

8 *Devon, Ottery St Mary. Fourteenth-century painted corbel. Stone death-head,*
 with gold foliage and berries. Foliage issues from mouth, sides of nose and centres of
 eyes. Felicity Howlett

9 *Devon, Ottery St Mary. Fourteenth-century corbel. The Green Man wears a hat and has neatly dressed hair and beard. The mouth is O-shaped and disgorges leaves and flowers which encircle a pillar cluster.* Felicity Howlett

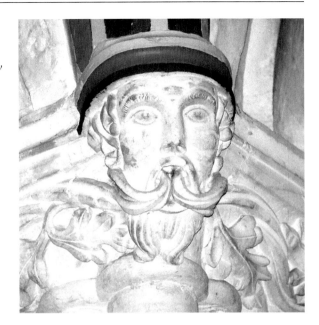

Anderson uses a Jungian interpretation of why there has been a sudden development of interest in recent years amongst writers, artists, musicians, art historians, architects and environmentalists: 'It was as though a sleeping archetype was waking up'. In addition to exploring the role of the Green Man in the past, he poses the question 'why is the Green Man returning to our awareness now and what does he want from us?'.

Anderson concludes that, in line with Jung's theory of compensation, 'the Green Man is rising up into our present awareness in order to counterbalance a lack in our attitude to Nature'. His suggested Jungian interpretation is that:

> An archetype such as the Green Man represents will recur at different places and times independently of traceable lines of transmission because it is part of the permanent possession of mankind. In Jung's theory of compensation, an archetype will reappear in a new form to redress imbalance in society at a particular time when it is needed. According to this theory, therefore, the Green Man is rising up into our presence awareness in order to counterbalance a lack in our attitude to Nature. (pp17 and 25)

This view is shared by Susan Clifford, the Director of the environmental organisation 'Common Ground', who said on the excellent *Omnibus* television documentary 'The Return of the Green Man' (1995) that:

People are feeling more and more beleaguered by what is being presented as the ecological crisis and it is absolutely convergent with the arrival of the Green Man. He seems to be coming back into the picture either because he's propelled himself or because we've called him to in some way walk with us through what seems to be very difficult times.

So is the Green Man arriving for the first time (i.e. is the coherence of the concept of the Green Man an entirely modern idea based on medieval images?) or is he returning, or has he been here all the time? Why are virtually all the ecclesiastical carvings of figures disgorging vegetation indisputably male? We have not come across a single disgorging figure which is indisputably female, though there are a few where the sex is difficult to determine. Susan Clifford sees him as male because his role is to protect:

> I think that one of the main explanations of the reason why the Green Man as opposed to the Green Woman, is that the Green Man is taking a part which is a protective part for, for example, the female forest or the Earth Mother.

But is he, or was he benign?

The one named early Green Man is carved on a fountain basin of *c*.1200 intended for the Cloister of the Abbey of Saint-Denis in France. It uses carvings of oak leaves and is inscribed 'Silvan' after the Roman woodland spirit Silvanus. The frequent use of oak symbolism, particularly in the English carvings, distinguishes the medieval Green Men carvings from their suggested origins in the Roman leaf masks and is suggestive of a different agenda. In one extraordinary glimpse into the medieval mind, a stone-carver at Chartres put carvings of Green Men disgorging vine, acanthus and oak side by side. The disgorging of foliage from mouth, sides of the nose, ears and forehead is another distinctive feature which generally separates the iconography of Roman and medieval Green Man carvings. However, there is one early example of a disgorging head, on the lid of the tomb of Sainte-Abre in the Church of Hilaire-le-Grand in Poitiers, which has been dated to the fourth or fifth century. This name is not listed in the Vatican and means literally 'St Tree'; an early Christian adaptation of a woodland spirit perhaps?

The profusion of Green Men carvings from the late twelfth century onwards which we will be exploring in this book are paralleled by ecclesiastical carvings in France and Germany. And, as we will show, folk customs which might shed some light on the superstitious beliefs of the stone and wood carvers in Britain, Germany and France appear to have an affinity. The absence of disgorging foliate heads for a period of nearly 700 years in

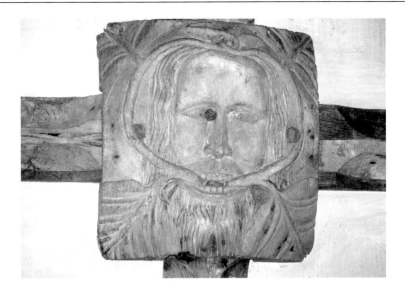

10 Devon, St Andrew, Sampford Courtenay. Fifteenth-century wooden boss.
Curling branches with strongly veined leaves issue from the Green Man's mouth
and interlock on the crown of his head. His hair flows loosely as does his beard.
Felicity Howlett

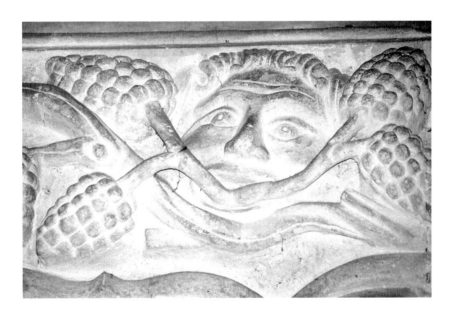

11 Devon, South Molton. Fifteenth-century chancel pier. A branch encircles the brow
of the Green Man while massive branches bearing grapes and vine leaves spring
from his mouth. Felicity Howlett

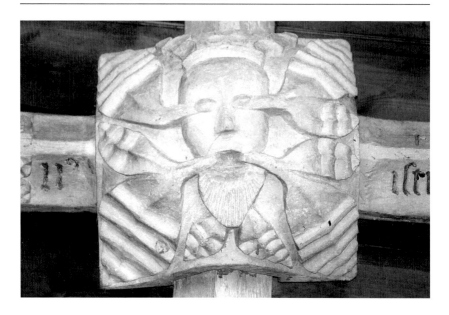

12 Devon, St Michael the Archangel, Spreyton. Fourteenth- or fifteenth-century death-head roof boss in chancel with mouth and eye foliage. The skull appears to be crowned and has a neat, leaf-shaped beard. Felicity Howlett

western Europe is obviously a significant factor in considering the cultural, and possibly religious, significance of the later carvings, and whether these have any connection with the disgorging head at Hilaire-le-Grand or with the earlier leaf masks of Bacchus surviving in Europe. In considering the latter, the number of Green Man carvings associated with the vine and/or grapes could be of significance. No significant traces of a Green Man myth exist, but we will explore traces of a figure of superstition in Britain called 'the Man in the Oak' and relics of oak worship. Again in this case Green Man carvings associated with oak leaves and/or acorns could be an important association.

Our study will focus particularly on the British Isles and will embrace ecclesiastical carvings, folk customs, symbolic figures and works of culture which may relate to, or have been inspired by, the concept of the Green Man. The folk customs we give details of in the British Isles are all ones we have attended (in most cases on several occasions). We have also quoted Sir James Frazer's accounts of some similar Eurpean customs (some of them now extinct) because these have influenced recent revivals of British customs and have also influenced the attitudes of previous writers considering a possible link between the ecclesiastical carvings of the Green Man and folklore and custom.

Our quest for the Green Man will begin with a consideration of the cultural and religious significance of the colour green.

2 Greenness

As a part of our examination of the pedigree of the Green Man, it is relevant to discuss the symbolic value of the colour green to Western civilisation, to the Celtic, Germanic and Christian religions relevant to early British culture, to any folkloric associations which might be meaningful to the woodcarvers and stone masons of the medieval cathedrals and churches, and even to a sophisticated man such as the Gawain Poet.

The colour green is both the colour most redolent of the natural world and of vegetation, growth and renewal, and the colour associated in traditional British cultures (and in some other parts of the world) with the extension to the natural world — the supernatural in both its 'Otherworld' and afterlife elements.

That in many parts of Britain the colour has been, and to some extent still is, regarded as an unlucky colour is not coincidental — it is a related facet. However, this has been offset in recent years by the development of a 'green culture'. Whereas green cars, green pullovers, and green shirts for football teams (Plymouth Argyll being a rare exception) were regarded as unlucky by many, nowadays green bathrooms and green bedrooms are seen to be soothing, environmentalists wear green wellies, a friendly green dragon, Desmond, is linked to advice to children on taking anti-asthma inhalants, and a Green Man symbol indicates safe crossing on the road and the green traffic light gives the 'all-clear' sign on the roads. There is also a 'Green Directory' of environmental organisations. Symbols are fluid and their significance can change to reflect shifting cultural changes and perceptions. An example of this is the changing cultural attitudes to the mythical dragon, which is increasingly regarded as friendly and an endangered species in films and children's stories. Mermaids too are perceived more as victims than dangerous aggressors in modern culture. Perhaps our ancestors did not view the associations of the colour green or the attributes of the Green Man in quite such a cosy way as we do today.

In alchemy the colour green was a positive symbol, the colour of the green lion or dragon, which was the 'raw material' at the beginning of the alchemical process in the quest for the elixir of life. The Celts, to whom the natural and supernatural worlds were closely linked, regarded the colour favourably and still do so in many parts of Ireland. It really seems to be Christianity which gave the colour green its negative imagery and this was because the

13 *Glos, St Michael & All Angels, Bishop's Cleeve. Twelfth-century capital. The Green Man has a heart-shaped, bearded quasi-animal face with high placed ears; highly stylised branches and leaves exit from the mouth and encircle the capital.* Felicity Howlett

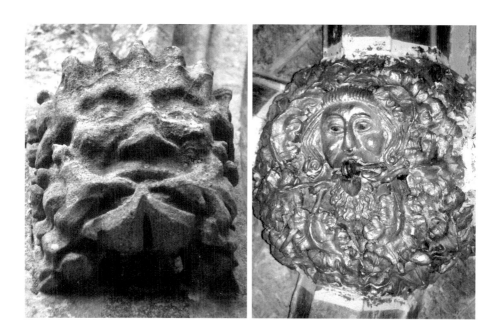

14 *(left) Glos, St Peter & St Paul, Northleach. Exterior stone boss. The Green Man has high cheekbones with a foliate branch over the bridge of the nose and a massive leaf issuing from the mouth. The 'ridged' hair is highly stylised.* Felicity Howlett

15 *(right) Glos, Tewkesbury Abbey. This Green Man with a protruding tongue is on the vaulting of the ambulatory and has fashionably dressed curling hair and beard. He appears to bite on a pole which holds a cage of greenery.* Felicity Howlett

Christians associated the colour with fertility (especially sexuality), paganism and the supernatural. Medieval Christianity, despite the enlightened efforts of thinkers such as St Francis of Assisi, had a problem with the natural world and the forces of nature. Unlike the Celts, the Christians emphasised the supremacy of man over the rest of God's creation. And the emphasis of the importance of virginity and chastity in Christian theology, which probably derives mainly from its Eastern roots, always sat uneasily in relation to Western societies.

There have indeed been periodic flirtations between Christianity and the World of Nature: St Francis, the awakening of humanism in the sculptural imagery (including Green Men) in Chartres and Exeter Cathedrals, the Oxford and High Anglican movements, and the links between the present Anglican Church and the Green Party. But often religious iconography has connected the colour green, fecundity and sexuality with the Devil, or with the pagan deities who influenced his portrayal.

An example of this comes in the ballad of 'Tamlin', frequently collected in the late eighteenth and early nineteenth centuries, the first recorded mention being as a well-known story in 1549. Tamlin seems to derive power to seduce Janet from her wearing a green mantle and because Janet damages trees in a wood belonging to him. In the version featured by Sir Walter Scott in his 'Minstrelsy of the Scottish Border — Young Tamlane', Janet is forbidden to go to Carterhaugh because:

> There's nane that gaes by Carterhaugh
> But maun leave him a wad,
> Either gowd rings, or green mantles,
> Or else their maidenheid.

She disregards the advice and 'has kilted her green kirtle/A little abune her knee', and is confronted by Tamlin at Carterhaugh.

Tamlin is a prisoner in Fairyland (Janet calls him 'an elfin grey'), the concept of which originates from traditions of the Celtic Otherworld, but by the sixteenth century Fairyland is linked to Hell in the ballad (Fairyland pays a 'teind (tithe) to Hell'). Thus a non-Christian concept such as Fairyland is given a Christian dimension by being linked to Hell, and the green symbolism of growth and vegetation is linked, in a probable distortion of the earlier significance of the story, into the negative sexuality of rape in some of the versions. The real significance of the colour symbolism of green and the relationship between Janet and Tamlin is brought out at the end of the ballad where Janet seeks the release of Tamlin by magical means from Fairyland to be the father of her child, by accommodating his shape-changing by the Fairy Queen into many dangerous shapes, until he is changed into a naked man,

whereupon she claims him by wrapping him in her 'green mantle /And sae her treue love wan'.

The Christian subtext added to the supernatural story of Tamlin is part of the Christian process of demonising elements from earlier cultures or from more recent superstitions. Thus the Celtic Otherworld and its development into the concept of Fairyland are given devilish connotations; the same happens with green symbolism. We can see this process at work in the fourteenth century alliterative romance *Sir Gawain and the Green Knight* (see chapter 5). The reaction of Arthur's knights and retainers to the Green Knight's appearance and his green horse bursting in on their Midwinter feast in the first fitt is: 'Forthy for fantoum and fayrye the folk there hit demed' (therefore the folk there deemed it to be an illusion and magical). By the time that Gawain has tracked down the Green Chapel in the fourth fitt he found that:

> Hit had a hole on the ende and on ayther side,
> And overgrowen with gres in glodes aywhere,
> And all was holw inwith, nobot an olde cave
> Or crevisse of an olde cragge, he couth hit noght deme
> With spelle.

> (It had a hole at the end and on the other side,
> and it was overgrown with grass in patches everywhere,
> and inside it was hollow, nothing but an old cave,
> or a fissure of an old crag, he couldn't say which).

(*Sir Gawain and the Green Knight*, lines 2180-4)

In the early Irish stories, supernatural figures are often associated with the Tuatha De Danaan, a Bronze Age people accredited with supernatural powers, driven to live underground in the mounds of the sidh (an Irish word meaning 'fairy mound'). These mounds were in reality Bronze Age and earlier burial mounds. Miranda Green in her *Dictionary of Celtic Myth and Legend* says that 'The burial mounds of the Neolithic and Bronze Ages were long believed to be the dwelling-places of the Irish gods'. In the Irish epic 'The Tain', a company of women in green tunics carry the body of Fraech, just slain of Cuchulain, into the 'sid', giving the hill its name of 'Sid Froich'. Such mounds also have magical significance in the Welsh stories of 'The Mabinogion', written down in the fourteenth century, and in British folklore.

Gawain makes the typical Christian fourteenth-century interpretation that once the Green Chapel turns out not to be a Christian site but a natural one, it must be devilish:

16 Hampshire, Winchester Cathedral. One of a series of fighting Green Men carved on spandrels in the choir. Carver William Lyngwode c.1308. Geoff Doel

'We! Lord', quoth the gentyle knight,
'Whether this be the Grene Chapel?
Here myght aboute mydnight
The Devel his matynes telle.'

('Alas Lord', said the noble knight,
'Is this the Green Chapel?
Here at midnight,
the Devil could say his matins!')

(*Sir Gawain and the Green Knight* lines 2185-8)

Gawain goes on comment:

> Certainly it is desolate here . . . This oratory is evil-looking and
> overgrown with herbs. It certainly seems that the man clad in
> green performs his devotions here, on the Devil's behalf. Now
> in my five senses, I perceive that it is the fiend who has imposed
> this appointment on me, to destroy me here. This is a chapel of
> disaster, and may ill luck befall it. It is the most cursed church that
> I ever came to.

(*Sir Gawain and the Green Knight* lines 2189-96; all these translations
by the authors)

Presumably the Gawain-poet himself does not share Gawain's prejudices
as he gives much wider associations to the mysterious figure of the Green
Knight in the context of the poem as a whole and is alert to, and presumably
influenced by, the resonance of folklore and earlier literature and oral tales
(he says at the beginning of the poem that he heard the story told 'in the
town', but this might just be a narrative convention).

D.W. Robertson, in an article entitled 'Why the Devil Wears Green', describes
the association of the colour green with devilry in Chaucer's 'Friar's Tale'. The
Friar is telling a story against summoners, and the summoner in his tale rides into
a 'grene-wode shawe' (the greenwood side) to wait for his prey, where he meets
a hunter who 'hadde upon a courtepy of grene' (wore a green upper short coat),
who admits to being a 'feend . . . fer in the north contree' (a fiend from far in
the north country). Supernatural visitants or fiends in disguise often come from
the north, as in the ballad of 'The Outlandish Knight', very popular in the folk
tradition, of which Thomas Hardy heard a version in Dorset *c*.1850.

Robertson's article also draws attention to Pierre Bersuire's fourteenth-
century Encyclopedia, a 'moralisation of the natural world', which includes a

chapter on the significance of the colour green, which includes meaning 'in bono' (good) and 'in malo' (evil). Robertson interestingly comments:

> In the course of his discussion Bersuire points out that green is a pleasant colour so that beasts like it and are attracted to green places. Hunters who seek beasts in such places dress in green so as not to forewarn their victims and so as to appear pleasant themselves. This fact suggests the techniques of that old hunter, the devil . . . The Friar's devil clearly fits this description. He is a hunter dressed in green seeking his prey 'under a forest syde'.

Robertson's analysis could also well have relevance to our understanding of *Sir Gawain and the Green Knight*. Green as a colour of enchantment is reinforced by the Scottish folktale 'Greensleeves', which is about a powerful enchanter who has links with fairy folk and the Lincolnshire tale about the 'Green Mist', which is raised by the supernatural bogles as a sign that spring has arrived. Interestingly the story says that the bogles do evil deeds in the winter, but helpful deeds with the onset of the growing season. Both these stories are discussed by Katharine Briggs in her *A Dictionary of Fairies*.

Lowry Charles Wimberley draws attention to the widespread significance of the colour green in the early folksong and ballads:

> In British folksong the colour green is occasionally associated with the dead or with death. The fairies and witches of balladry likewise favour this colour, and it is possible that here again we encounter a significant resemblance between the dead and fairies. Greenness as a trait of supernatural beings — fairies, dwarfs, ghosts, and even animals — occurs in the folktales of many lands. Green is an unlucky colour for a bride in 'Lord Thomas and Fair Annet': 'I'll na put on the grisly black, nor yet the dowie green'. This is illustrative of the ill omen that in general attaches to green . . . Dreaming of pulling green heather, green apples, or green 'birk' (birch) is premonitory of death in 'The Braes o Yarrow'.

(*Folklore in the English and Scottish Ballads*)

One of the ghost babes in a Motherwell copy of 'The Cruel Mother' is clad in green: 'The neist o them was clad in green/To shew that death they had been in.'; the drowned girl in the Campbell text of 'The Twa Sisters' has a 'ghaist (ghost) sae green'; and 'Death is greener than the gress' (grass) says Captain Wedderburn, in answer to one of his lady's riddles (in the riddling ballad 'Captain Wedderburn's Courtship').

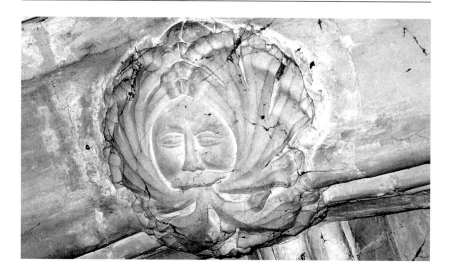

17 Hampshire, Winchester Cathedral. From the narthex. Geoff Doel

Many British ballads and folksongs bring green vegetation into their refrains (just as many have floral or herbal refrains). One of the earliest is the mysterious 'Green Grow the Rushes O', a counting song which refers to many early symbolic figures. As well as having the title as a refrain after each verse, this song includes has a verse about the 'Lillywhite Boys dressed up all in green-o'. Further examples include 'The Cruel Mother' (in which the mother slits her twin babies' throats) which includes the refrain 'Down by the greenwood side-o'; 'The Keeper', with the refrain 'Among the leaves so green-o', and 'The Shoemaker's Kiss', with the refrain 'So green as the leaves they are green, green, green, green, So green as the leaves they are green'.

Katharine Briggs comments thus: 'Green is generally acknowledged to be the fairy colour, particularly in Celtic countries, and for this reason is so unlucky that many Scotswomen refuse to wear green at all'. She also relates that 'greencoaties' is a Lincolnshire name for fairies and that 'greenies' is a Lancashire title for fairies.

The legendary Robin Hood is usually described as being dressed in Lincoln or Kendal green in the early ballads and in accounts of his representations in the May Games and in pageants in the sixteenth century. This would be the functional attire for a forester, but the emphasis on Robin as a green-clad figure does verge on the symbolic, particularly when he takes on the role of the Summer Lord in the May Games, from the fifteenth century if not before. Robin Hood is inextricably associated with the greenwood and may also be associated with the woodland spirit Robin Goodfellow, who appears in Shakespeare's *A Midsummer Night's Dream* with his alternative

title 'Puck'. An example of the association of Robin Hood with greenery and the celebration of the onset of Summer is given in Hall's chronicle account of Henry VIII and Queen Catherine of Aragon going a-Maying and being 'captured' by Robin Hood' in 1516:

> The King and the quene, accompanied with many lords and ladies, roade to the high grounde on Shooters hill to take the open ayre, and as they passed by the way they espied a company of tall yeomen, clothed all in grene, with grene hoods and bowes and arrowes, to the number of two hundred. Then one of them whiche called hymselfe Robyn Hood, came to the kyng, desyring hym to see his men shote, and the kyng was content. Then he whistled, and all the two hundred archers shot and losed at once; and then he whisteled again, and they likewyse shot againe; their arrows whistled by craft of the head, so that the noyes was straunge and grat, and muche pleased the kyng, the queen, and all the company. All these archers were of the kynges garde, and had thus appareled themselves to make solace to the kynge. Then Robyn Hood desyred the kyng and quene to come into the grene wood, and to see how the outlawes lyve. The king demaunded of the quene and her ladyes, if they durst adventure to go into the wood with so many outlawes. Then the quene said, if it pleased hym, she was content. Then the hornes blewe tyll they came to the wood under Shooters Hill, and there was an arber made of bowes, with a hall, and a great-chamber, and an inner chamber, very well made and covered with floures and swete herbes, whiche the kyng muche praised. The said Robyn Hood, Sir, outlaws' breakfast is venison, and therefore you must be content with such fare as we use. Then the kyng and the quene sate doune, and were served with venison and wine by Robyn Hood and his men, to their great contentacion. Then the kyng departed and his company, and Robyn Hood and his men them conducted; and as they were returnyng, there met with them two ladyes in a ryche chariot drawen with five horses, and every horse had his name on his head, and on every horse sat a lady with her name written And in the chayre sate the lady May, accompanied with lady Flora, richly appareled: and they saluted the kynge with diverse goodly songs, and so brought hym to Grenewyche. At this maiying was a greate number of people to beholde, to their great solace and comfort.

(from Joseph Ritson's *Robin Hood*, 1795)

Perhaps the carvings of Green Men in medieval cathedrals and churches, the traditions of greenwood spirits and the legends of the greenwood outlaw are all fuelled by the same sources of inspiration and cultural association.

According to medieval chronicles, two green children were actually discovered in Suffolk. Keightley's nineteenth-century *The Fairy Mythology* gives a translation of the Latin of Ralph of Coggeshall's original Latin account:

> Another wonderful thing happened in Suffolk, at St Mary's of the Wolf-pits. A boy and his sister were found by the inhabitants of the place near the mouth of a pit which is there, who had the form of all their limbs like to those of other men, but they differed in the colour of their skin from all the people of our habitable world; for the whole surface of their skin was tinged of a colour green. No one could understand their speech. When they were brought as curiosities to the house of a certain knight, Sir Richard de Calne, at Wikes, they wept bitterly. Bread and other victuals were set before them, but they would touch none of them, though they were tormented by great hunger, as the girl afterwards acknowledged. At length, when some beans just cut, with their stalks, were brought into the house, they made signs, with great avidity, that they should be given to them. When they were brought, they opened the stalks instead of the pods, thinking the beans were in the hollow of them; but not finding them there, they began to weep anew. When those who were present saw this, they opened the pods, and showed them the naked beans. They fed on these with great delight, and for a long time tasted no other food. The boy, however, was always languid and depressed, and he died within a short time. The girl enjoyed continual good health; and becoming accustomed to various kinds of food, lost completely that green colour, and gradually recovered the sanguine habit of her entire body. She was afterwards regenerated by the laver of holy baptism, and lived for many years in the service of that knight as I have frequently heard from him and his family, and was rather loose and wanton in her conduct. Being frequently asked about the people of her country, she asserted that the inhabitants, and all they had in that country, were of a green colour; and that they saw no sun, but enjoyed a degree of light like what is after sunset. Being asked how she came into this country, with the aforesaid boy, she replied, that as they were following their

flocks, they came to a certain cavern, on entering which they heard a delightful sound of bells; ravished by whose sweetness, they went for a long time wandering on though the cavern, until they came to its mouth. When they came out of it, they were struck senseless by the excessive light of the sun, and the unusual temperature of the air; and they thus lay for a long time. Being terrified by the noise of those who came on them, they wished to fly, but they could not find the entrance of the cavern before they were caught.

Another chronicler, William of Newbridge, dates the event to the reign of King Stephen in the twelfth century and says that the girl called her country 'St Martin's Land' and that its inhabitants were Christian.

This story could stem from some actual event, such as the discovery of two wild children, but if its origins are mythical then it is interesting that beans are said to traditionally be the food of the dead and that the colour green can be linked with both death and the magical Otherworld. The paradoxical forces that the colour green can symbolise — life and death, this world and the next, natural and supernatural, positive and negative, reality and illusion — suggests that either there is a deliberate ambiguity about the symbolism of the colour, or that it has changed its significance for the different cultures we have been examining. Plus, there are other interpretations — green as an indication of the unfledged and naïve, presumably a metaphor taken from the early green phase of growth in vegetation, and the peculiar identification of the colour with jealousy. Iago (in Shakespeare's *Othello*) calls jealousy 'the green-ey'd monster, which doth mock/That meat it feeds on'. As it is usually sexual jealousy which is the problem when the colour green is used in this way, perhaps it is a link with the fertility aspect of the colour — a highly dubious association in the eyes of the medieval Church.

There was a positive use of the colour green by the medieval Church, however, and this was in the liturgy. From the very early days of Christian worship there developed a symbolic use of colours in associated with seasonal worship in vestments, altar-hangings, chalices, and veils in which green seems, naturally enough, to represent germination and growth. Pope Innocent III (1198-1216) outlined a general approach for the Roman church, using white for feasts, red for martyrs, black for penitential seasons and green at all other times. More specifically, in 1570 a general rule for the Catholic church decreed the use of green for liturgical trappings on Sundays between Epiphany and Lent and on ordinary weekdays. It seems that, as far as the Church was concerned (and perhaps more generally) green and yellow were regarded as interchangeable colours symbolically.

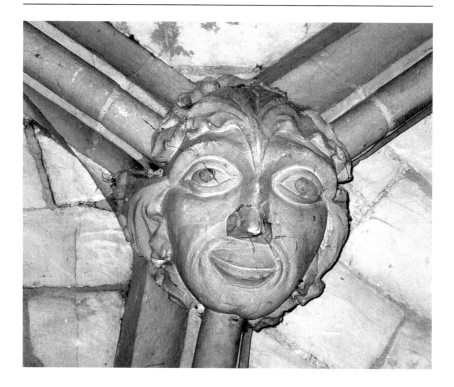

18 Hampshire, Winchester Public School. Stone boss in the porch. Geoff Doel

With such a complex, shifting and contradictory symbolism pertaining to the colour green in European religious and secular culture, it is small wonder that the significance of the Green Man is so hard to pin down.

3 Ecclesiastical carvings

There is no evidence of ecclesiastical carvings of the Green Man in Britain before the late Norman period. He is featured in stone, and later wooden, carvings in cathedrals, monasteries and churches from the late twelfth to the early sixteenth centuries, his rapid decline coinciding with the rise of Protestantism. A new phase in Green Man carvings was introduced by Victorian Gothic carvers and restorers, and there have also been twentieth-century examples.

In the Norman period some rudely carved non-naturalistic heads in association with highly stylised vegetation make a rare appearance as a decorative feature in a few great churches, parish churches and cathedrals, usually on corbels and the capitals of stone pillars, and many would identify these as the first Green Men in Britain. With the rise of Gothic architecture in England in the thirteenth century, heads become the most numerous type of decoration on bosses, and the 'grotesque head' in particular enjoys great popularity, and some Green Men are featured. But his true popularity comes in the fourteenth and fifteenth centuries, with hundreds of surviving stone and wood bosses. (Stone bosses are a part of the structure of a vaulted stone roof; wooden bosses are decorative with no practical purpose and outnumber the stone bosses in British ecclesiastical buildings.) It is perhaps significant that the Green Man as a symbol of the life force found greatest representation in ecclesiastical buildings after the Black Death, a virulent and deadly plague which cut the population by a third and destroyed communities.

Commenting on late medieval boss carving in his book *Roof Bosses in Medieval Churches* (p21) Cave says, 'The style of carving the whole keystone, often with very deeply cut designs, was peculiarly English. In France in early times the style was for the lower surface of the boss to consist of a flat plaque with rather shallow carving.'

No one is sure how important it is to identify the foliage that inevitably accompanies the Green Man when the foliage is not a fruit bearing or inhabited vine scroll (an early traditional symbol of Christ, the Christian faith and the Eucharist). In the Gothic period the Green Man is carved on stone roof bosses, first of all surrounded by or disgorging a stylised form

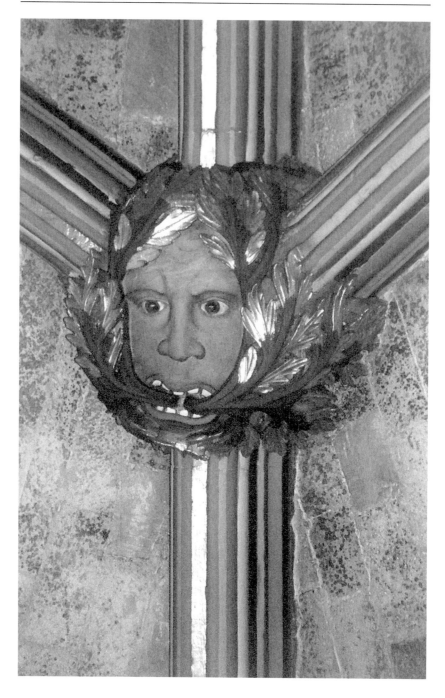

19 Devon, Exeter Cathedral. Painted roof boss in the Lady Chapel. The mouth has been pushed into an irregular shape by two foliate branches which grow from within and reach upwards to enclose the head in foliage. Felicity Howlett

of vegetation which is termed English 'stiff-leaf' or trefoil, then (from 1270-1310) with an increasingly profuse and often beautifully executed naturalistic foliage based on real botanical specimens such as the oak, hazel, vine or rose after which 'conventional' foliage replaces the naturalistic; the 'conventional' leaves, in J.C.P. Cave's words in *Medieval Carvings in Exeter Cathedral*, are instantly identifiable because they are 'undulating and lumpy'. Green Men feature on both stone and wooden bosses.

Sadly, attempting to access the super-mythical Green Man in order to determine what the Green Man meant to medieval man and woman is as difficult and possibly as thankless a task for us today as it was for earlier scholars in the nineteenth and early twentieth centuries; they were well aware of his 'presence' as an artistic representation, but had not yet coined the phrase 'Green Man' and used instead the term 'foliate head' or even more vague 'grotesque'. The word 'grotesque', which is Italian in origin, dates to the late fifteenth century and is a reference to the discovery and excavation of Roman remains in that period and the kind of decorations found on antique Roman murals, such as floral motifs, masks, human figures and non-realistic animals. Writing in the mid-twentieth century and possibly voicing the views of those in the twenty-first century, Cave comments on the Green Men as subjects (p68): 'those who have noticed them have looked on them as fancies of the carvers. But I consider the motive to be much too definite and that it must have had some meaning that was well known to the sculptor.'

Although the Green Man does occasionally survive as a carved motif on medieval domestic architecture, we have seen only two: one was carved in a fifteenth-century ale house in Sussex, and the other was from the exterior of an early sixteenth-century house in Colchester. The vast majority can be seen in remarkable profusion as roof bosses in the naves and cloisters of great churches and cathedrals. Noting that they had once been brilliantly coloured, Cave suggests that these 'heads with stems of plants coming out of their mouths' possibly only survived because they were roof bosses, high up and therefore presumably difficult to access by the waves of religious reformers in the sixteenth century and by the even more virulent iconoclasts of the seventeenth century who were anxious to deface or obliterate all traces of saint and Marian worship, the sacraments, the sacrifice of the mass and the 'real presence'. It is even more likely that their survival (along with more accessible Green Man carvings) is because they were inoffensive in religious terms. Enthusiastic church restorers of the nineteenth century, though their motivation was different, also contributed to the destruction of medieval interiors.

The great churches and cathedrals of medieval Britain were edifices normally shared by a monastic order (usually male) and a parochial

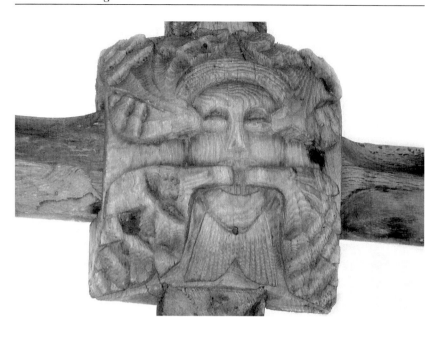

20 Devon St Andrew, Sampford Courtenay. Unpainted rectangular fifteenth-century foliate wooden boss with massive wide-leafed branches issuing from the corners of the eyes and the mouth of a death-head. The beard is trimmed into a fashionable 'fish-tail' shape. Felicity Howlett

congregation, and the Green Man appears both in the special space allocated to those in holy orders such as the choir and the sacristy, as well as that assigned to the laymen (the aisles, nave, transept, side and ambulatory chapels etc.). Though the Green Man is most often seen in the stone or wooden bosses high up in the roof, he is often also present on the corbels (projecting brackets, jutting from an interior or exterior wall), is carved on tombs and on chantry chapels (medieval chapels within a church in which perpetual prayers used to be recited for the souls of the founders), and appears in great profusion on the underside of the tip-up seats of the misericords in the choir. These seats, also known as 'indulgence seats' date mainly to the fourteenth and fifteenth centuries and were particularly designed to help aged or inform clerics perform their liturgical duties.

All monks and canons in religion saw their principal function as the glorification of God through the monastic offices: Mattins, normally sung in the small hours after midnight, then through the day a long succession of services, Lauds, Prime, Tierce, Nones, Vespers and Compline. These consisted of fairly brief prayers and praise in which the community prayed, sang and recited psalms. High Mass, the climax of worship, was celebrated

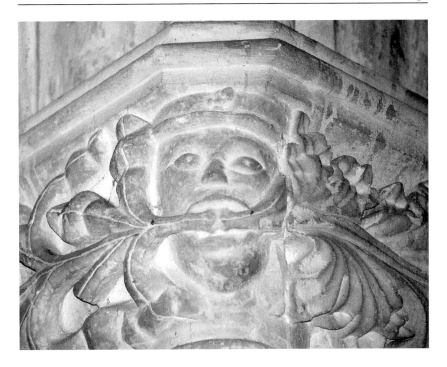

21 Devon, South Molton. Fifteenth-century stone capital. The brow is bound by a thick branch and sturdy branches disgorge from a gaping mouth. Felicity Howlett

during the day and there were possibly additional private masses celebrated for the benefactors of the community. All these ceremonies were celebrated by the community standing in beautifully carved individual wooden stalls in the choir which were sited at the east end of the church near to the high altar. As Francis Bond says, 'by the use of these misericords the monks and canons were able to comply with the ancient discipline where it enjoined a standing position, while at the same time obtaining a little support and change of posture'. The hinged underside of the misericord, which would clatter down with a deafening noise if the sitter fell asleep, was carved on the underside with all kinds of figures and foliage, some taken from bestiaries, some from folklore, fabliaux material or from scripture. The Green Man, foliage issuing from brows, nose, eyes and mouth or a combination of the same, is a favourite motif here, either as the centrepiece flanked by 'supporters' or occasionally as the 'supporters' themselves.

Outside the great church or cathedral the Green Man's presence is often particularly noticeable in the cloister complex which, when it was associated with male religious orders, was constructed to the south of a cathedral or large church and functioned as passage way, library and study area as well

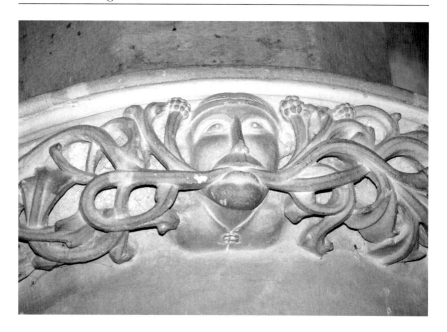

22 Herefordshire, St Bartholomew, Much Marcle. The Green Man is on the capitals of a pillar in the nave and is dated to c.1230. He wears a headband and a necklace (although it may be a clasp fastening to a tunic) and vine branches and grapes grow in profusion from his mouth. Felicity Howlett

as linking the house of God with the domestic quarters. Because so many of the latter were slighted or robbed out after the Reformation there is little surviving to indicate whether the Green Men was used as an iconographic decorative feature in these — the parlour, where conversations were conducted and guests received, the infirmary, the refectory, the warming room, used for recreational purposes and where the monks were bled, the scriptorium etc. Fortunately there are a number of surviving chapter houses attached to cathedrals in which the community met daily to conduct business, hear confession and listen to a reading of a chapter from the rule, and here the Green Man often has a presence.

Most of our parish churches which were built in a variety of materials including wood were *in situ* in British towns and settlements by the end of the eleventh century; little of this early fabric survives, however, as most were substantially rebuilt, extensively remodelled and refurbished in subsequent centuries, but the main shape is normally that of a western tower attached to a chancel which might be apsed. It is not unknown for the Green Man to be carved on exterior corbel tables amongst a number of other 'grotesques', presumably with the function of warding off evil.

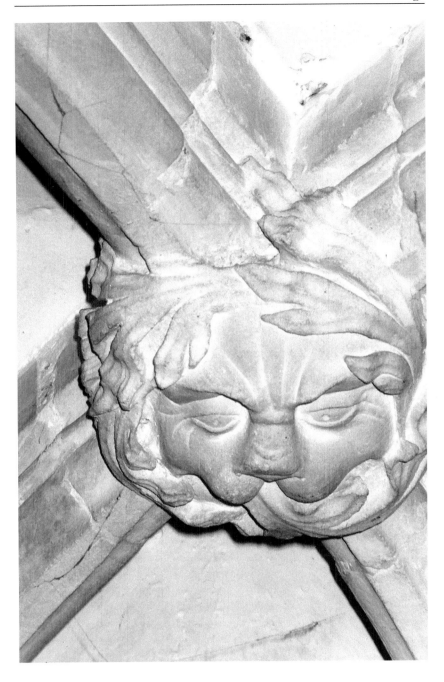

23 Kent, Canterbury Cathedral, Canterbury. Green Man on tomb of St Anselm's Chapel. Geoff Doel

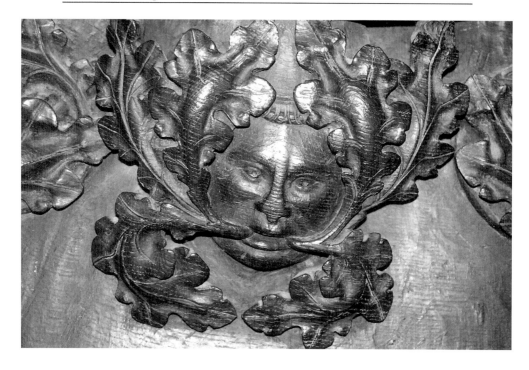

24 Norfolk, St Margaret's Church, King's Lynn. Fourteenth-century misericord. The Green Man has a neatly cut fringe and is beardless. Huge oak leaves protrude from the corners of his mouth. Felicity Howlett

Inside the medieval parish church the seating arrangement for parishioners was very limited, usually a simple matter of a few fixed seats against the interior wall or piers paid for by church benefactors and intended for the use of pregnant women and the old and infirm. The rest of the congregation (like the monks and canons in their stalls) were expected to stand or kneel at designated moments of the mass. By the fifteenth century, however, backless wooden benches began to be introduced, soon to be improved with traceried backs and elaborately carved bench ends, and arranged so as to create a large central aisle and also to leave broad passages from the nave to the north and south doorways to permit processional activity. The bench ends were often given an ornamental finial known as a 'poppy head' from the Old French word *puppis* meaning a figure head. The thousand and more fifteenth-century bench-ends of Somerset, particularly in the Quantock and West Somerset area, are justifiably famous for the quality and interest of their bench ends and 'poppy heads' carvings. Devon is believed to have a similar number of surviving bench ends, and there are amazingly even more in Suffolk and Norfolk. It is on these bench ends,

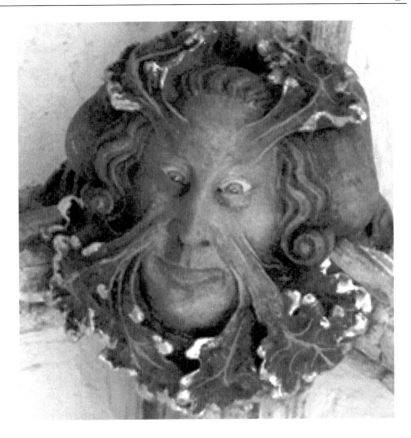

25 Norfolk, Norwich Cathedral. Often referred to as 'demonic', this Green Man in the south cloister with his curling neatly dressed hair and enigmatic smile is made sinister by a living foliate mask which grows from his green nose. Felicity Howlett

along with myriad other subjects religious and secular, that the Green Man makes a consistently regular appearance. The subject of English bench end carvings is notably covered by J. Charles Cox's *Bench Ends in English Churches*, and M. Cautley's *Norfolk and Suffolk Churches*, and A. Gardner's *Minor English Wood Sculpure*.

The font, screens and pulpits in the medieval parish church are remarkable for their lack of Green Man representation. Perhaps this is because they more usually carried doctrinal and scriptural messages in their sculptures. Fonts, for example, can be carved with representations of the sacraments, the pulpits with the early fathers and the four evangelists, and the screens which divided the choir from the nave painted with images of the saints, some historical and many apocryphal.

A feature of the medieval church was the areas within church space which could be acquired by a local wealthy family; the space could then be used as a private family chapel, as a chantry chapel in which perpetual prayers could be recited for the souls of the founders in purgatory, and where there could be burials or masses. The Green Man can often be found as a decorative carved motif here, and is even sometimes presented as a 'weeper', i.e. a weeping mourner.

Popular as they were in stone and wood, Green Man images are very rare in stained glass and wall paintings, two mediums which particularly portray religious messages, and most often indicate devotion to Christ or the Virgin as mother of God. His absence could be used as circumstantial evidence that images of what we now call 'the Green Man' had no universally specific Christian significance or symbolism in the Middle Ages. But the omission of surviving evidence can be interpreted differently. So much medieval glass was destroyed in the sixteenth and seventeenth centuries that it is now impossible to say if the figure once appeared more regularly as a motif in church windows; or indeed if the Green Man was additionally used as a design on floor tiles, paintings, funerary brasses, reliquaries, bells and a variety of other medieval items that were described as 'relics, images and other trash' by Henry VIII's men and accordingly cleared out of churches and destroyed or melted down before being redeployed. The profusion of Green Man carvings (perhaps the most dominant secular image in medieval churches, except foliage itself) in the stone bosses, interior and exterior stone corbels, and in the wooden misericords and bench ends, can either be interpreted as the survival of more durable, less vulnerable materials, or as the result of no religious control or censorship of images on those particular items. Bosses, corbels, misericords and bench ends do feature a myriad of mythological and folkloric symbols and scenes in addition to biblical, liturgical and related textual material. The lack of examples of defaced mythological and folkloric material could be offered as evidence that the Green Man was part of this topos which Protestant and Puritan defacers did not identify as a religious threat.

Indeed, Anderson (*Green Man*, p134) gives example of the Green Man being used as a motif on the continent in Protestant printed works. These include bibles and theological treatises, either in the borders of plates or as colophons to chapters, and one shows the title page of Luther's *Appellatio ad Concilivm*, (Appeal to the Council), Wittenberg, dated to 1520. It features a foliate head with cornucopias issuing from its nostrils, from which burgeon greenery and flowers and on which are poised, on the left, a venerable male preacher with pointed finger admonishing or directing a modestly attired woman who is positioned on the right and reading a book, which one presumes must be the bible.

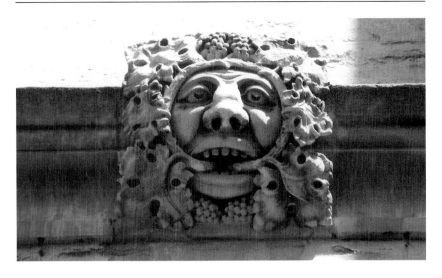

26 Oxfordshire, Magdalen College, Oxford. Exterior stone carving facing main street. This heavy-featured Green Man has deep-set eyes, a thick-set nose and a wide, thick-lipped mouth. Grape bearing branches from the corners of his mouth curl round to form a frame for his face. Felicity Howlett

And so, despite the Green Man's continuing presence in the shells of beautiful ecclesiastical buildings that once glowed with colour and were pungent with the smells of incense and wax candles, we are still unable to say with any certainty how our Green Man was interpreted by medieval man and woman. The Green Man after all is not a liturgical, legendary or bestiary figure, easily explained by text; other alternatives are that he may have been suggested by pre-Christian classical material, or pulled out of the imagination. But out of whose imagination? The carver's? Is it feasible that the Church, which in certain areas of Britain during this period was almost neurotically suspicious of Lollardy within the community, would not insist on total ecclesiastical control of the symbolism employed within the house of God? Or can we accept that, as G. Challis claims (*Life in Medieval England — as Portrayed on Church Misericords and Bench Ends*, p45), the late medieval carver was unequivocally 'not prepared to accept the straight jacket of strict Christian belief' and therefore given *carte blanche* to introduce the Green Man along with any number of carved figures from secular medieval life into church and cloister? As Cave points out (*Medieval Carvings in Exeter Cathedral*, p17), the problem lies in the fact that there are no contemporary written documents that can enlighten us regarding this kind of figurative representation, and 'the real question arises of how the subjects were selected, what models the sculptors had to work from, whether the subjects were

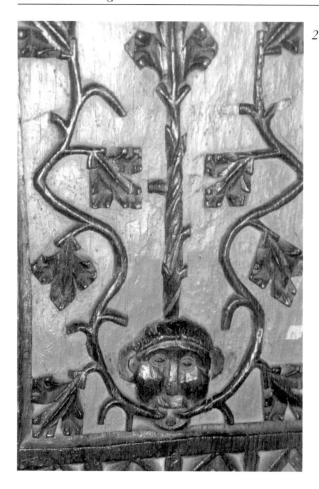

27 Somerset, St Mary's Church, Bishops Lydyeard. A fifteenth-century bench end. This crudely carved representation shows a man's head with pudding basin hair cut and protruding ears. A tree with lopped branches grows from the crown of his head and foliate branches issue from the corners of his mouth and reach high above his head. Felicity Howlett

chosen for them, or whether they carved their figures according to their own fancy. We have nothing definite to go on and can only give probable answers to these problems.'

Two fundamental questions remain to be considered: why do these carvings emanating disgorging vegetation in nearly every case only show their heads, and why are these heads invariably male? The head as a symbolic representation of the whole body and as the vessel which contains the soul is a common feature of art and religion from as early as the Celtic period. The foliage as life force emanates from the head of the Green Man as the universe was considered as issuing from the essence of God. To medieval man the creative life force in religious terms was seen as being male, for a male Godhead without consort had created the world and all that was within.

4 The spirit in the tree

Nineteenth-century scholars seeking to de-codify the disturbing uniqueness of the Green Man were prepared to relate the grotesque head to the myriad other carvings. These were more easily interpreted symbolically and could be demonstrated from text (sermons, saints' lives, bestiary books) to indicate an essential moral teaching, initially interpreted the Green Man as symbolic of God's creation — mortal man as part of nature and therefore subject to God's laws, who receives life as a gift and is subject to mortal man's cycle of life and death. Interpreted in this way, the Green Man as an emblem of man's mortality, and as a *memento mori* image must be seen as totally appropriate in its use in chantries, Easter Sepulchres, and tombs. The iconography of a fifteenth century stone coffin lid in St Giles, Bedon, Worcestershire, illustrates this well. Here the crucified Christ appears stretched out on a cross which is presented as a tree with lopped off branches. The cross is surmounted not by the superscription reading 'King of the Jews' (as told in the Gospels) but by a Green Man. If the Green Man represents the inevitability of man's mortality it is also an oblique reference to the mortality of the couple who have commissioned the tomb and whose portraits appear on the coffin lid. Their released souls are represented by two doves resting on the cross which is also symbolically portrayed as a tree. The crucified body of Christ, his body tense as if he is still experiencing the agony of his voluntary suffering, is for medieval man representative of the corporeal humanity of the Saviour who is both God and man and whose unique sacrifice gives promise of eternal life to his creation, mankind.

In their study of the decorative and symbolic design of *The Bosses and Corbels of Exeter Cathedral* written in 1910, E.K. Prideaux and G.R. Holt Shafto were among the first not entirely to reject, but to modify the Victorian iconographic interpretation of the Green Man as 'an allegory of the creative energy (i.e. mankind) of the Deity, especially where, as in many cases, the foliage-stalks issue from the eyes and ears as well as from the mouth'. Prideaux and Shafto's objection to the Green Man as a form and symbol of the sacred were based on aesthetics, their belief that the sacred could not manifest itself in concrete forms which appeared to *them* as profane. They described how the visual presentation of the Green Man is often given 'a grotesque and distorted visage without a trace of any attempt of the portrayal

28 Hampshire, St Cross, Winchester. Fifteenth-century foliate head on vaulting in north aisle. Geoff Doel

of divinity in its treatment'. Other writers have since commented on this apparently 'demonic' look and accepted what is now often referred to as 'the two ways of presentation, the benign and the demonic', though few have thought fit to consider whether medieval man might have perceived or interpreted the sacred in a different light. Christ, for example, is variously portrayed in medieval church paintings not just in a human shape, but as hideously tortured humanity, or presented with a leprous body, or in zoomorphic form, as unicorn, phoenix, lion, hart, pelican, calf, ram or lamb.

It also became accepted for many scholars in the late nineteenth and early twentieth centuries to explain the enigmatic Green Man in terms of his possibly pre-Christian origin. Today theories of origin tend to be regarded at best as doubtful and at worst as unverifiable, and the question of whether medieval man was even conscious of emblematic origins, classical or pagan, was rarely addressed. Inevitably not just new but conflicting theories emerged. Prideaux and Shafto suggest that the 'foliate face' was conceivably rooted 'in

29 Herefordshire, St Michael, Garway. Chancel arch twelfth-century pillar capital. Horned or helmeted Green Man with branch or band binding the brow. The mouth disgorges highly stylised ribbon interlacing branches. The leaves are so stylised that they have become abstract. Felicity Howlett

the (ancient Greek) actor's dramatic mask which furnished a general type for all faces with disproportionally large mouths' which, they point out, originated in Bacchic celebrations, and which in ancient times were 'often hung in vine-yards as a sort of classic scarecrow'. The Bacchic/Dionysian link was eagerly explored by students of the esoteric who now began to see the Green Man as the spiritual ancestor of the death and resurrection gods of Graeco-Oriental cults, Tammuz, Dionysis and Adonis, whose colourful and bloody myths and elaborate rites are now interpreted by anthropologists as manifestations of early man's anxiety regarding the fertility of the soil and the succession of the seasons.

Cave was one of the first to reject the classical origin theory and opt for indigenous cultic custom and pre-Christian belief. In his book, *Medieval Carving in Exeter Cathedral*, he writes 'I suppose that it (the Green Man) may be a survival from tree worship which had come down through the Middle Ages, just as Jack in the Green has come down almost to our own days', a conclusion shared by Lady Raglan (see chapter 1). For Frazer, the Summer King or Jack in the Green ceremonies of the European peasantry

were a survival of a type of cultic sacrificial ritual which in antiquity had involved the 'The Golden Bough' devoted to tree worship. Frazer explores the development of the primitive religious stage of the concept that each tree had a soul or divinity into the more sophisticated religious belief of a spirit moving from tree to tree or into the wider cosmos:

> When a tree comes to be viewed, no longer as the body of the tree-spirit, but simply as its abode which it can quit at pleasure, an important advance has been made in religious thought. Animism is passing into polytheism. In other words, instead of regarding each tree as a living and conscious being, man now sees in it merely a lifeless, inert mass, tenanted for a longer or shorter time by a supernatural being who, as he can pass freely from tree to tree, thereby enjoys a certain right of possession or lordship over the trees, and, ceasing to be a tree-soul, becomes a forest god. As soon as the tree-spirit is thus in a measure disengaged from each particular tree, he begins to change his shape and assume the body of a man.

The first primitive stage of tree worship is exemplified by the veneration of the maypole by Germanic and Celtic peoples across Europe, a good example being the famous description by the puritan Phillip Stubbes in his *Anatomie of Abuses* published in 1583:

> Against May, Whitsonday, or other time, all the yung men and maides, olde men and wives, run gadding over night to the woods, groves, hils, and mountains, where they spend all the night in plesant pastimes; and in the morning they return, bringing with them birch and branches of trees, to deck their assemblies withall. And no mervaile, for there is a great Lord present amongst them, as superintendent and Lord over their pastimes and sportes, namely, Sathan, prince of hel. But the chiefest jewel they bring from thence is their May-pole, which they bring home with great veneration, as thus. They have twentie or fortie yoke of oxen, every oxe having a sweet nose-gay of flouers placed on the tip of his hornes, and these oxen drawe home this May-pole (this stinkyng ydol, rather), which is covered all over with floures and hearbs, bound round about with strings, from the top to the bottome, and sometime painted with variable colours, with two or three hundred men, women and children following it with great devotion. And thus being reared up, with handkercheefs and flags hovering on the top, they straw the ground rounde about, binde

green boughes about it, set up sommer haules, bowers, and arbors hard by it. And then fall they to daunce about it, like as the heathen people did at the dedication of the Idols, whereof this is a perfect pattern, or rather the thing itself. I have heard it credibly reported (and that viva voce) by men of great gravitie and reputation, that of fortie, threescore, or a hundred maides going to the wood over night, there have scaresly the third part of them returned home againe undefiled.

This vivid and sensuous account is punctuated by lurid and sensationalised attacks on what Stubbes perceives to be pagan survivals and idol worship. The dramatic tension and fascinated horror is typically Puritan. But unpleasant killjoys as the Puritans undoubtedly were, they had an intellectual understanding of how elements of paganism had survived in customs and superstitions and even in the practises of the Roman Catholic faith.

The London Puritans directed their venom against the famous maypole which stood in front of the church of St Andrew Undershaft in Leadenhall Streeet; the church ('Undershaft') being named after the maypole. After a disturbance in 1517, the maypole was kept for 32 years under the eaves of a row of thatched cottages. Then the curate of St Catherine Cree preached against it at St Paul's Cross as an idol. The outcome, quoted much later by the Victorian *Penny Magazine* was:

> That the parishioners after they had dined, raised the pole off the hooks on which it had rested so many years, and each man sawing off for himself a piece equal to the length of his house it was quickly demolished and burned.

Henry Machyn mentions in his diary the breaking up of a Maypole in Fenchurch by orders of the Lord Mayor of London in 1552. So clearly the Puritans regarded the maypole as symbolic of paganism, as an 'idol'.

It is Frazer's second stage — what he describes as 'the tree-spirit . . . conceived and represented as detached from the tree and clothed in human form, and even embodied in living men or women' — which may have relevance to our quest for the cultural and mythological origins of the Green Man, and which has certainly influenced scholars in the early and mid-twentieth century.

Again Frazer illustrates his thesis with contemporary or recently extinct but documented folk customs, the most interesting of which is the account of the 'Green George' custom:

Amongst the Slavs of Carinthia, on St George's Day (the twenty-third of April), the young people deck with flowers and garlands a tree which has been felled on the eve of the festival. The tree is then carried in procession, accompanied with music and joyful acclamations, the chief figure in the procession being the Green George, a young fellow clad from head to foot in green birch branches. At the close of the ceremonies the Green George, that is an effigy of him, is thrown into the water. It is the aim of the lad who acts Green George to step out of his leafy envelope and substitute the effigy so adroitly that no one shall perceive the change. In many places, however, the lad himself who plays the part of Green George is ducked in a river or pond, with the express intention of thus ensuring rain to make the fields and meadows green in summer. In some places the cattle are crowned and driven from their stalls to the accompaniment of a song

'Green George we bring,
Green George we accompany,
May he feed our herds well,
If not, to the water with him.'

A third stage described by Frazer is where the representation of the tree-spirit 'by a tree, bough, or flower is sometimes entirely dropped, while the representations of him by a living person remains. In this case the representative character of the person is generally marked by dressing him or her in leaves or flowers; sometimes, too, it is indicated by the name he or she bears.' Frazer illustrates this stage by another 'Green George' custom:

In some parts of Russia on St George's Day (the twenty-third of April) a youth is dressed out, like our Jack in the Green, with leaves and flowers. The Slovenes call him the Green George. Holding a lighted torch in one hand and a pie in the other, he goes out to the cornfields, followed by girls singing appropriate songs. A circle of brushwood is next lighted, in the middle of which is set the pie. All who take part in the ceremony then sit down around the fire and divide the pie among them. In this custom the Green George dressed in leaves and flowers is plainly identical with the similarly disguised Green George who is associated with a tree in the Carinthian, Transylvanian, and Roumanian customs observed on the same day.

Here we see that the same powers of making rain and fostering the cattle, which are ascribed to the tree-spirit regarded

as incorporate in the tree, are also attributed to the tree-spirit represented by a living man.

One wonders if Frazer is correct about the distinction between the second and third stages, or whether the interesting customs he has researched do not all largely represent a hybrid man-tree connection (just as the ancient concepts of the mermaid and werewolf represent hybrids between woman and fish and man and wolf, or the Celtic horned god a link between man and horned beast).

For instance the 'Little Leaf Man' custom from Ruhla described by Fraser does seem to symbolise an innate link between man and nature, or more specifically between man and the cycle of the seasons through the re-emergence of vegetation in the Spring:

> In Ruhla as soon as the trees begin to grow green in spring, the children assemble on a Sunday and go out into the woods, where they choose one of their playmates to be the Little Leaf Man. They break branches from the trees and twine them about the child till only his shoes peep out from the leafy mantle. Holes are made in it for him to see through, and two of the children lead the Little Leaf Man that he may not stumble or fall. Singing and dancing they take him from house to house, asking for gifts of food such as eggs, cream, sausages and cakes. Lastly, they sprinkle the Leaf Man with water and feast on the food they have collected.

The perambulation through a community with a ritual celebration, collecting gifts of food and drink or money from bystanders or householders, is a common feature of European traditional customs and symbolises a link between that community and the seasonal forces of nature. The connection between the performance and the reward/gifts ensures good luck (i.e. fertility and well-being, avoidance of natural disasters etc.).

Fraser thought he detected elements in the European 'Green Man' customs suggestive of sacrifice to ensure the fertility of nature:

> Thus the killing of the representative of the tree spirit in spring is regarded as a means to promote and quicken the growth of vegetation. For the killing of the tree spirit is associated always . . . implicitly, and sometimes explicitly also, with a revival or resurrection of him in a more youthful and vigorous form.

What Frazer sees as sacrificial elements could be viewed as symbolic representations of the annual cycle of growth/rebirth, and many English May

30 Herefordshire, Hereford Cathedral. Stone fragment. The Green Man is recessed into an ornamented shape. Oak leaves emerge from his closed mouth as does a split tongue. Felicity Howlett

customs significantly lack the sacrificial elements Fraser claimed to have detected in wider Europe. The Jack in the Green, for example, has no hint of death or sacrifice in its many English forms, except in the Hastings revival which was influenced by a reading of *The Golden Bough*. However the death and revival of the Padstow Obby Oss (Mayday) and Earl of Rone at Combe Martin (originally Ascension Day), and what could be viewed as a decapitation of the Castleton Garland King (Oak Apple Day), may have sacrificial elements.

In both the classical origin theory and the indigenous Jack in the Green origin theory, the god/king cannot be understood except in relation to a sacred tree — in psychological terminology one of the Jungian 'archetypal symbols'. Without the foliage, the Green Man becomes, after all, simply Man. The question surely is, therefore, what does 'The Tree' represent?

For medieval man, interpreting the symbol of the tree probably held no mysteries. Since his childhood the Church had been continuously instructing him how to distinguish and unravel its various levels of Christian meaning and complexity — through sermons which often drew on apocryphal and

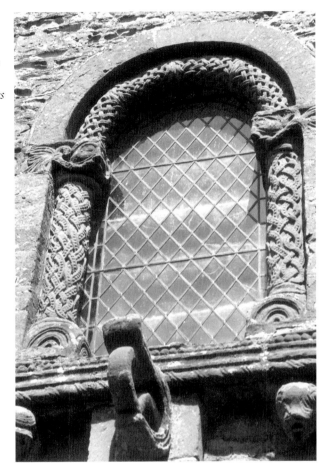

31 Herefordshire, St Mary & St David, Kilpeck. Green Men disgorge branches and leaves of an abstract nature. They are inset into the capitals of a highly ornate ribbon interlace surround to a twelfth-century window and exude immense energy and movement. Felicity Howlett

legendary as well as biblical material, wall paintings, mystery and saints' plays, saints' lives, and the liturgy with all its attendant rituals.

One of its central, and perhaps its most obvious, meanings is that of the genealogical tree of Christ, known as the Tree of Jesse. It was often pictorially presented in medieval stained glass, wall paintings, illuminations and woodcarvings, and shows the ancient and recumbent Jesse from whose loins springs a living tree which culminates in Christ as a human baby held in the arms of his human mother, the Virgin, in fulfilment of the prophecy of Isaiah (11: 1-2) that a Messiah would spring from a line of kings, the house of David.

No less an important meaning is that The Tree is *the* cross of the crucifixion (the latter often termed 'the Tree' in medieval poetic text and sermons), which enabled God as Man to fulfil the prophesies on behalf of mankind and is therefore a symbol of individual man's salvation.

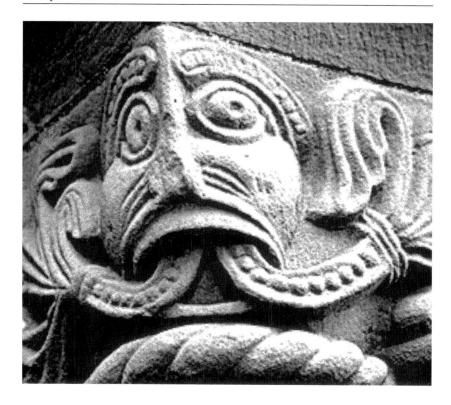

32 Herefordshire, St Mary & St David, Kilpeck. Carved detail from a twelfth-century doorway. The Green Man is so stylised as to have lost all his humanity. His eyebrows and the vegetation exuding from his mouth carry the same patterning. Felicity Howlett

> Now god pat dyed on a tre geve vs grace
> No worse to be Amen, amen for charyte.

(Gower, Confessio Amantis 1, 3067-3402)

The close relationship of Christ and the Tree is further developed in the cruciform shape chosen by the church to represent the house of God, in which God's sacrifice is eternally being played out in the form of the mass. The pictorial representation of the Man in the Tree (the Green Man) may originally have contained this symbolism, for the church itself was regularly represented as a tree. Medieval man may possibly have been unaware that in antiquity the cross was a symbol of shame or that the role of the cross is not dwelt with at length in the gospel accounts, but that was no matter for there

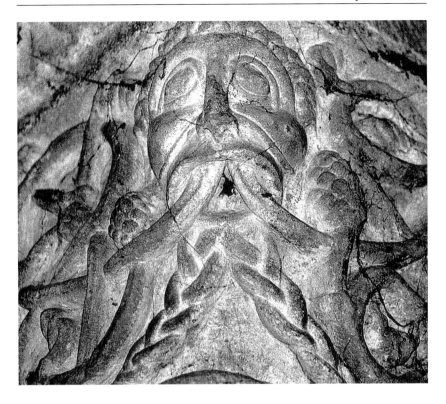

33 Herefordshire, Priory Church of St Peter & St Paul, Leominster. This Green Man, on a twelfth-century capital, has curled dressed hair and a long plaited beard. He disgorges great thick branches of fruiting vine leaves. Felicity Howlett

were any number of stories which informed him of the magical cross/tree. It was believed, for example, from an account in the *Apocrypha* that all trees had bled during the crucifixion and would do so again on the Final Day of Judgement. This same text also informs us that at this time the Cross would arise in the skies, resplendent in glory, as a herald of the Second Coming of Christ after which it would conduct through the skies all those who were to dwell in perpetual glory with their Lord and Saviour. Yet another medieval legend (the Pseudo-Chrysostom interpretation of Isaiah, 1 x.13) claimed that the cross had been fashioned from the wood of four trees — the cypress, the cedar, the pine and the box — while an earlier Anglo-Saxon poem, the Anglo-Saxon Riddle L.Vss favoured the 'maple, oak, the hard yew and holly' as the trees which were blessed through association with Christ's Passion.

Following St Helena's 'discovery' of the 'true cross' in the fourth century with its superscriptions, nails and crown of thorns, hundreds, possibly thousands, of churches in Christendom had been flooded with holy relics

34 Kent, Parish Church of St Peter & St Paul, Tonbridge. This roughly carved Green Man dated c.1400 has ivy leaves springing from his mouth and is carved in a beam above the piscina in the Chapel of St Nicholas. The head is known locally as 'the silent watcher'. Photograph by kind consent of Davyd Power

purporting to be miracle-working pieces of the True Cross, the tree on which the Saviour died. Two great feasts were later instituted and became popular church festivals in which the Cross was venerated: the Exaltation of the Holy Cross (14 September) and the Invention of the Holy Cross (3 May). On Good Friday the faithful were invited in a dramatic ceremony described in Duffy's *The Stripping of the Altars*, to creep barefoot to the cross, where they kissed the crucifix, after which it was wrapped in linen cloths and 'buried' in the Easter Sepulchre with a consecrated pyx, representing the body of Christ. The Easter Sepulchre disappeared from our churches during the Reformation but was once a regular architectural feature and consisted of a sacred space, often in a niche or tomb, usually on the north side of the chancel, or failing this a timber construction, and always with a rich cloth covering. On Easter morning the Sepulchre was censed, the pyx restored and the crucifix brought forth in triumph and processed round the church to the peeling of bells, after which the choir sang *Christus Resurgens* and the congregation was once again invited to creep on their knees to adore the Saviour's 'Tree'.

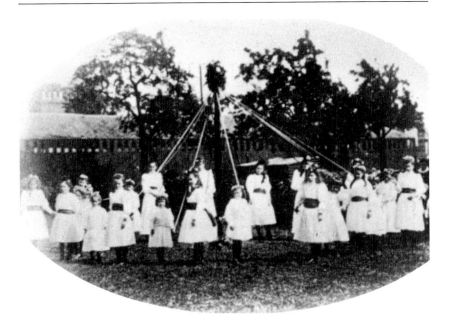

35 The Maypole Dance at Dartford, Kent, c.1896

These feasts and ceremonies, which in effect celebrated the image of the Cross as the 'Tree of Glory', were apparently enormously popular. In the thirteenth century a Latin work, *The Golden Legend*, written by a preaching friar named Jacobus de Voragine to be used as sermon material, became so popular that it was afterwards translated into every Western European language. Caxton brought out its English translation in 1483. Its influence was thought to be enormous. In this work appear two colourful and apocryphal True Cross legends. Voragine, dealing with the Church's liturgical calendar, describes both the Feast of the Finding of the Holy Cross and the Exaltation of the Holy Cross, and in these traces the Cross's mythical history before and after the crucifixion. Voragine's legendary material tells us that the sacred cross grew from three seeds taken from the Tree of Knowledge from God's Paradisial Garden by Seth who was seeking the Oil of Mercy; it was he who placed the seeds in old Adam's mouth in his earthly grave, thus permitting the Tree of Life to grow on earth. In the fullness of time the sacred tree was cut down on the order of King Solomon but magically resisted being utilised so that his carpenters in despair cast it into a deep pond. At the time of Christ's ministry, according to Voragine, the sacred tree floated of its own accord to the surface of the water whereupon it was taken and fashioned into Christ's cross of the crucifixion. Voragine gives us its legendary history after the crucifixion. He tells us that in the seventh century a pagan Persian

61

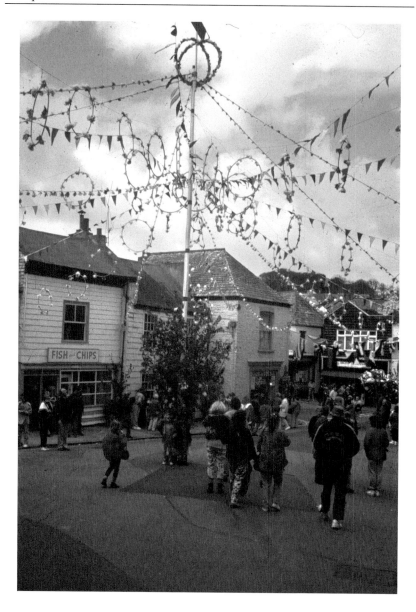

36 The Maypole, Padstow, Cornwall, 1992. Geoff Doel

Emperor conquered the world and stole the sacred relic of the Holy Cross from its venerated place in the Church of the Holy Sepulchre. In time it was rescued by the Christian Emperor Heraclius who returned it to the Holy City, whereupon it demonstrated its sacred powers through a series of healing miracles. These stories, probably very much enjoyed by the public, would probably not have been perceived by the uneducated man as anything other than factual.

During the medieval period the closeness of identification of the body of Christ with the Sacred Tree led to a further identification of the Cross as the Church, and, as such, an emblem of the Christian religion. To illustrate this, early crucifixes made no attempt to show a suffering Christ on the cross. Instead the Christ was clothed in a long rich robe reaching to the feet, his arms lying stiffly along the transverse beams, and his feet placed neatly together on a ledge with no signs of wounds and nails. Other early carvings are thought to illustrate the hymn *Vexilla Regis*, which begins '*Regnavit a ligno Deus*' ('God reigns from the tree'), and in these the crucified figure of Christ is robed as a king and he is royally crowned. Ultimately, the tree as cross is a symbol of the sacrifice of a god-king, his death and resurrection. The Green Man, linked as he is to the tree which is God's creation, may well share the cross's protean symbolism.

5 Sir Gawain and the Green Knight

When the figure we now call the Green Man was at its peak of popularity in stone and wood ecclesiastical carvings at the end of the fourteenth century, a remarkable poem was composed in north-western England — perhaps Derbyshire, Cheshire or Lancashire — which might throw some light on the symbolic significance of the figure in culture and folklore at this time.

The author of *Sir Gawain and the Green Knight* has not been identified, but the poem survives in a unique manuscript with four other poems, three of which (and possibly all four) are clearly by the same author. The best of the others, 'Pearl', is a moving poem concerning the death of the poet's two year old daughter, who appears to him in a dream-vision, to ask him to cease mourning as she is in paradise and his grief disturbs her. This poem, as with all the Gawain-Poet's work, combines the philosophical and religious with an intense humanity.

The writer of these four or five poems is deeply religious, highly cultured and sophisticated, and well versed in symbolism and numerology. He is part of a group of writers in the north of England who revived the ancient Anglo-Saxon alliterative style of poetry, which relies of rhythm and a pattern of stressed words beginning with the same consonant (or vowels) instead of rhyme. These alliterative poets seem to be deliberately 'little Englanders', writing against the French and Italian influences which were helping to mould the content, and particularly the style and metre, of their southern contemporary, Chaucer. Many of these late alliterative poems deal in a patriotic manner with what was known as 'The Matter of Britain', the cycle of Arthurian adventures, which by the late fourteenth century was regarded as being rather out of date on the European mainland.

Sir Gawain and the Green Knight combines two folktale motifs — 'the beheading contest' and the 'exchange of winnings' — but treats them in a highly sophisticated and symbolic way which is distinctly the author's own. It is the beheading context which frames the story in the first and last fitts (sections) which may be relevant to the Green Man. A remote, probably indirect, source for this is the eighth-century Irish tale *Fled Bricrend* ('Bricriu's

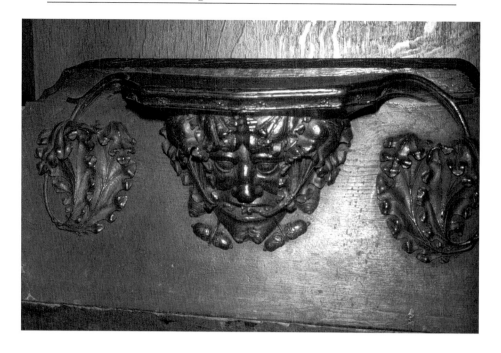

37 Lincolnshire, Lincoln Cathedral. Finely carved late fourteenth-century misericord.
Geoff Doel

Feast'), from the Ulster Cycle, which is available in Jeffrey Gantz's translation in his collection *Early Irish Myths and Sagas*.

In the Irish story, three heroes compete in various ways for the champion's portion — to sit at the right hand of the king and to be served the best portions of food at the feast. Several people, including Ailill and Medb, King and Queen of Connacht, try unsuccessfully to mediate between the claims of the three heroes, Loegure Buadach, Conall Cernach and Cu Chulaind. Eventually the heroes are sent for judgement to Uath, a magician with druidic powers of shape-shifting. He tests the heroes by inviting them to cut off his head with an axe and to come for a return blow the following day. One version of the story recounts that Loegure and Conall refuse the challenge on the grounds that the wizard has the supernatural power to remain alive after beheading, which they do not. Another version has Loegure and Conall both cutting off Uath's head on separate occasions and failing to turn up for the return blow. Both versions have Cu Chulaind fulfilling the bargain completely, by cutting off Uath's head and by returning the next day to receive the return blow. Three times Uath reverses the blade and lays it on Cu Chulaind's neck and he proclaims him the supreme warrior of Eriu (Ireland) and worthy of the champion's portion.

The disputes continue and the god Cu Rui tests the heroes in various ways. He finally disguises himself as an ugly churl and approaches the hostel (court) at Emuin Machae, holding a tree trunk in his left hand and an axe in his right hand, reminiscent of the Green Knight's approach in King Arthur's Hall carrying a bob of holly and an axe. Cu Rui also wears a large bushy tree on his head, large enough to house 40 calves. In his introduction to the story, Jeffrey Gantz comments that Cu Rui's colour is given as '*glass*', which can signify either grey or green in the Irish language. Again he offers an exchange of axe blows and Cu Chulaind is again the only hero willing to receive the return blow and to prove his courage and fidelity to his word. The duplication of the beheading motif may be a conflation of two versions of the story.

In *Sir Gawain and the Green Knight* there is also an outlandish visitor (who actually proves to be very sophisticated) who bears symbols of the outside world of nature and bursts into a New Year feast with a weird challenge, directed at King Arthur's knights. The description of the Green Knight should be examined both from its significance in the context of the general folklore and symbolism of the late fourteenth century, and in terms of the intellectual and symbolic context of the poem. In other words, what would his appearance signify immediately to the readers of the poem? And what does he represent in terms of the poem itself? The former point may seem the more relevant to our quest for the Green Man, but the latter is of interest with regard to the poet's attitude to the popular culture of his day.

This is how the Green Knight's entrance is described in the First Fitt:

> Scarcely had the noise of the music ceased for a moment and the first course been seemly served in the court, when there hurries in at the hall door a fearsome knight, one of the largest in the world of high stature. From the neck to the waist he was so squarely built and so thickset, and his loins and limbs were so long and so powerful, that I believe he was half a giant on earth, but at any rate I declare him to be the biggest of men and at the same time the shapeliest of stature that might ride. For in back and breast his body was of forbidding appearance, but his paunch and his waist were worthily small, and all his features matching in the form that he had very elegantly. People marvelled in wonder at his hue, plain to see in his features. He bore himself like a man who would be bold and was overall a bright green.
> (ll 134-150)

> (This and all subsequent translations of sections of *Sir Gawain and the Green Knight* are by Fran and Geoff Doel from editions of the original text by Davis & Burrow (see notes and bibliography).)

The knight is described as fearsome and very tall ('half-etayn'— 'half a giant'), but well-proportioned. His green colour is held back until the very last line of the stanza for dramatic effect. The next stanza begins by picking up the colour association revealed at the end of the previous stanza, showing that his clothing is also green:

> And all arrayed in green was this man and his clothes. A tight-fitting cloak very straight which stuck to his sides, and a comely mantle above, adorned with trimmed fur exposed to view, the edging very neat with very bright resplendent ermine, and his hood as well, which was set back from his locks and laid on his shoulders. He had well pulled up hose of that same green that were fastened to his calves and bright spurs below of bright gold upon silk bands richly decorated with stripes. And the man rides there shoeless below his shanks. And all his garments were truly entirely bright green, including the bars of his belt and the bright gems which were richly arrayed on his bright raiment about himself and his saddle, upon silk embroidery. It would be difficult to tell of half the trifles that were embroidered above with birds and butterflies, in gay and gaudy green, with gold always in the midst. The pendants on the horse breast trappings, the proud crupper, his studs and all the metal was enamelled, and the stirrups that he stood on were similarly coloured. So were the saddle-bows behind him and his noble saddle-skirts that continually gleamed and glinted with green stones. The steed that he rode on was certainly equally resplendent, a great and sturdy green horse, a steed difficult to control, restive in its embroidered bridle, a most suitable horse for the knight.
> (ll 151-78)

The emphasis here is on the sumptuous and costly clothes and jewels that the knight is wearing. For he is clearly no untutored wild man of the woods. A recent televisation of the poem showed the Green Knight as our modern personification of the Green Man, as a kind of overgrown cabbage, but this is not how he is described in the poem. He is a knight, wearing up-to-date sophisticated gear, though the lack of shoes and the long hair mentioned in the next stanza alert the reader, in combination with his colour, to something supernatural.

The stanza just quoted also modifies the green symbolism, by blending it with gold as far as the vestments are concerned. This double colour symbolism of green and gold continues throughout the poem, and is one of several linking points between the 'beheading contest' and the 'exchange of

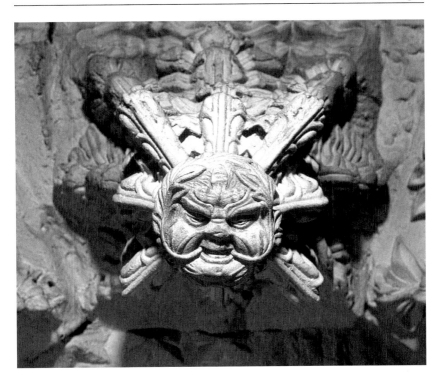

38 Midlothian, Rosslyn Chapel, Scotland. Fifteenth-century stone pendant, retrochoir. Seven ornately carved non-naturalistic rigid leaves frame the head while two curving foliate branches disengage from the mouth and curve round the dimpled chin, cheeks and brow. The bridge of the nose and forehead are carved with a non-naturalistic image of a tree. There is a disturbing quality about the Green Man's expression. Photograph by kind permission of Antonia Reeve, Rosslyn Chapel Trust

winnings' section. The girdle which Bercilak's wife gives to Gawain in Fitt 3, whose concealment by him causes all the problems, is 'worked with green silk and shaped with gold', as is found in colouring associated with Green Men stone and wood carvings in some cathedrals and churches (though some of the colouring is in Victorian and twentieth-century restorations and it is difficult to ascertain what evidence was left of the original colouring). The Green Knight is also riding a green, supernatural horse.

The next stanza extends the descriptions of the wealthy ornaments and decorations on rider and horse, emphasises the profusion of hair and mane of rider and horse, and carefully and emphatically associates the green and gold colour symbolism:

39 Norfolk, St Margaret's Church, Kings Lynn. Fourteenth-century arm-rest. The Green Man disgorges foliage with berries.
Felicity Howlett

Very fair was this man fashioned in green, and the hair of his head matched his horse. Comely fanning hair enfolds his shoulders. A beard as great as a bush hangs over his breast, which with his splendid hair extended from his head and was trimmed all around above his elbows, so that half his arms were covered under it in this way, like a king's hood that encloses his neck. The mane of that mighty horse was much like it, well curled and combed, with a great many knots, plaited with gold thread mingled with the beautiful green, always a thread of the hair with another of gold. The tail and his forelock were similarly twined and both were bound with a bright green band, ornamented as far as the

tail extended with very precious stones, then tied with a thong, an intricate knot above, where many bright bells of burnished gold rang. Such a horse on earth, and such a person riding him, had never before been seen by those in the hall by sight. He seemed as bright as lightening, so all said who saw him. It seemed as if no man could survive his blow.

(ll 179-202)

Despite his ferocious appearance and a huge axe that he carries, the next stanza makes clear that the knight is not clad for battle, though he acts aggressively by riding up to the high dais, and the first words that he utters are rudely colloquial:

Nevertheless he had no helmet, nor hauberk either, nor a plastron or plate armour suitable for combat, nor a spear, nor a shield to shove with and smite. But in one hand he held a cluster of holly, which is greatest in green when groves are bare, and an axe in his other hand, huge and monstrous, a cruel axe to describe in words if anyone could. The large head had the length of an eln measuring rod (45 inches), and the edge was made of green and gold steel. The blade was polished brightly with a broad cutting edge, as well suited to shearing as sharp razors. The grim knight gripped it by the shaft of a stout staff, which was bound all the way up to the stave's end with iron and was all engraven in green with graceful designs. A thong was wound around it, fastened at the head and then hitched to the haft at intervals with many fine quality tassels attached to it on bosses of richly embroidered bright green. This man proceeds to enter the hall, makes his way to the high dais, he feared no danger. He greeted no one, but loftily he looked about. The first words he uttered were: 'Where is the governor of this gang?' Gladly would I behold that man with my eyes and talk with him. He cast his eyes on the knights and rolled his eyes up and down. He stopped and began to study who was there of most renown.

(ll 203-31)

John Burrow in his illuminating critical study 'A Reading of *Sir Gawain and the Green Knight*' emphasises the 'ambivalence' of the Green Knight's behaviour in the first fitt which 'is to be detected in his colour, in his behaviour, and in the adventure which he eventually proposes'. His green colouring suggests the supernatural, but his clothes suggest a youthful, sophisticated knight appropriate to Arthur's court. He is not a rude, unlettered man who behaves

40 *Norfolk, Norwich Cathedral, fourteenth-/fifteenth-century stone boss in St Ethelbert's Gatehouse. The Green Man grips an oak garland firmly with his teeth, the stem of which originates from within his throat. His hair is combed back off his face.* Felicity Howlett

and speaks rudely because he is churlish, but he is aware of the decorum he is offending. He rides up to the high dais knowing this to be offensive behaviour (unlike Perceval in the contemporary English poem 'Sir Perceval of Galles' who, as John Burrows points out, rides into Arthur's presence and addresses him as thou, the king realising that 'He was a wilde man' and therefore his behaviour is excusable. Here the Green Knight is being deliberately rude in behaviour and choice of words when he pretends not to notice King Arthur and enquires 'where is . . . the governour of this gyng?', which is as colloquially rude as it sounds to us today.

41 Norfolk, St Ethelbert's Gatehouse, Norwich. Fifteenth-century boss. A plump-faced Green Man holds two great leafy branches in his gaping mouth.
Felicity Howlett

The combination of battle axe and holly bob that he carries are symbolic and also highly ambiguous. The battle axe signifies the martial nature of the 'Cristmasse game' he is to propose, even though his 'wedes' (clothes) are, as he says 'softer' — he wears no armour. But the bob of holly can be taken as a peaceful symbol. Again John Burrows supplies a helpful comparison — the scene in Malory's *Le Morte D'Arthur* when Lancelot escorts Guinevere from Joyous Garde to Carlisle under safe conduct:

> Then Sir Lancelot purveyed him a hundred knights, and all well clothed in green velvet, and their horses trapped in the same to the heels; and every knight held a branch of olive in his hand in tokening of peace.

The Gawain Poet is clearly using the conventions of his own sophisticated society to some extent in his portrayal of the Green Knight, particularly in his dress, behaviour and speech, and the emblems which he carries. But clearly the figure is based on something more primitive, more rooted in Nature. His appearance on New Year's Day is highly significant. In Arthurian

42 *Norfolk, Norwich Cathedral. This boss is in the cloisters and is remarkable for the totally circular, teeth-fringed mouth spewing out two great leaves which encircle the Green Man's face. The Green Man has a luxurious head of hair, beard and moustache and his brow is deeply furrowed.* Felicity Howlett

terms it is one of Arthur's five feast days, but in early Welsh and Irish literature, supernatural occurrences tend to take place on the Irish New Year (Samhain) or the Welsh New Year, which is January by the time the stories in 'The Mabinogion' are written down. There are persistent traditions in British culture that the New Year provides a kind of rift in time, when it is particularly opportune for Otherworld visitants to come. Arthur's followers clearly regard the Green Knight as magical as the first part of the next stanza makes clear:

> There was looking at length to view the man, for everyone marvelled at what it might mean that a man and a horse should have caught such a colour as to grow as green as the grass, and greener it seemed, glowing brighter than green enamel on gold. All that stood there studied him and stalked nearer, wondering what in the world he would do. For many marvels had they seen, but never such as this before. Therefore the folk there deemed it to be an illusion and magical.

The Gawain poet is using the green symbolism both to evoke the supernatural and the natural world which are both entering Arthur's hall in

the person of this ambiguous visitant. The New Year is a time of hiatus in the cycle of growth, a crisis in the natural world which must have alarmed early man. To combat this, acts of sympathetic magic evolved to ensure the return of the sun to vigour and strength. Many of these customs became a part of the Midwinter and New Year festivities within the Christian society of the fourteenth century. And indeed the death and resurrection and sacrificial elements that can be detected in symbolic form amongst so many Midwinter customs are themselves part of Christian beliefs and forms of worship (particularly the Roman Catholic form of the fourteenth century). It is one of these practices that the Green Knight intends to invoke. He responds more courteously to Arthur's greeting (which ignored the Knight's rude behaviour) and praises the reputation of Arthur and his knights, though rather arrogantly asserting that none of the knights could match up to him in real combat ('Here about on this bench are but beardless boys. If I were clasped in armour on a high steed, there is no man here to match me, their might is so weak'). He compliments lead up to a request for 'a Cristmasse game':

> because your renown, man, is so highly exalted and your castle and your knights are held to be the best, the bravest in armour riding on steeds, the fiercest and worthiest of the human race, valiant to play with in other noble sports, and courtesy is made manifest here, as I have heard tell. And that has brought me here, certainly, at this time. You may be the surer by this branch that I bear here that I pass in peace and seek no strife. For had I set out in company in warlike fashion, I have both a hauberk and a helmet at home, and a shield and a sharp spear shining brightly, and other weapons to wield, I know well. But because I want no war, my clothes are softer. But if you are as bold as all men say, you will gladly grant me the game I ask by right. . . . Therefore I crave in this court a Christmas game, because it is Yule and New Year and here are many valiant men. If there is anyone who considers himself so hardy in this house, so bold in his blood and rash in his head, who dares unflinchingly to exchange one stroke for another, I shall give him of my gift this fine battle axe, which is heavy enough, to handle as he pleases. And I shall bide the first blow as I sit unarmed. If any man be so fell as to try what I speak of, let him leap lightly to me and latch hold of this weapon and keep it as his own — I renounce it for ever — and I will unflinchingly stand a stroke from him on this floor, providing you judge me the right to give him another in my turn. And yet give him a respite of a twelvemonth and a day.
> (ll 258-98)

There is no evidence in the poem that the Green Knight is specifically targeting Gawain in his challenge. The challenge is a general one to Arthur's knights, and when no one takes it up, Arthur offers to accept the Green Knight's challenge himself rather than see the Round Table shamed. It is that this point that Gawain, renowned in the English tradition for his courtesy and early Northern romances and ballads for getting King Arthur out of tight corners, modestly proposes that he should take on a contest which is far too bizarre to risk the life of the king over.

Gawain decapitates the Green Knight who, not altogether unexpectedly, survives, picks up his head and tells Gawain to meet him in a year's time at the Green Chapel:

> Make sure, Gawain, that you are ready to go as you promised, and search as faithfully until you find me, man, as you have promised in this hall in the hearing of these knights. I charge you to make your way to the Green Chapel, to receive such a dint as you have dealt — you deserve it — to be promptly given on New Year's morn. Many men know me as the Knight of the Green Chapel, therefore if you seek for me you won't fail to find me. Therefore come, or it will behove you to be called recreant.
> (ll 448-56)

One of the key themes of the poem is 'trawthe' (truth), a testing of Gawain's keeping to his pledged word. The importance of this is emphasised by the Green Knight's solemn, almost legal annunciation of their contract in front of witnesses. Gawain's 'trawthe' is linked into his knightly code, symbolised by the pentangle device on his shield; like the pentangle, Gawain's virtues and his ideals are inextricably linked together.

Gawain keeps his word by turning up for the return blow a year later and this is also a considerable test of his courage, to face what seems to be certain death. His seeking the Green Chapel becomes a personal quest and involves him in 'the exchange of winnings game' at Bercilac's Castle, where his truth, and consequently his knightly code, are a little undermined. The Green Knight acts as his confessor and judge at the end of the poem, two of the many roles this mysterious figure undertakes. His faults are not deemed severe, his motive in acquiring the green and gold girdle being in order to save his life (as he thinks), and his failure to declare receipt of it to Bercilac being to save the reputation of Bercilac's wife, who has given it to him as a love token (though he accepts it purely as a life-saving device) and asks him not to reveal it.

The Green Knight's explanation of the reason for his enchantment and decapitation, that it was wrought by Morgan Le Fay 'to have greved Guenore

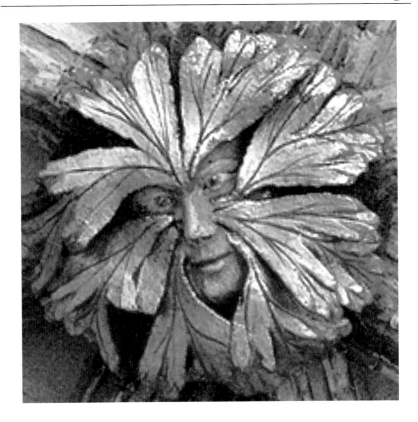

43 Norfolk, Norwich Cathedral. A clean-shaven Green Man peers from the vaulting of the cloister, deeply veined leaves growing from his cheeks and from between his eyes. The boss is in the east cloister and is dated to the early fifteenth century. Felicity Howlett

and gard hir to deye' ('to have grieved Guinevere and caused her to die') is totally unconvincing. As John Spiers put it in an early article for *Scrutiny*: 'The "explanation" — Morgan's envy of Guinevere — introduced rather perfunctorily at the end of the poem (from the literary source or "authority", perhaps) is, in effect, no more than a bone for the rationalising mind to play with and be kept quiet with'.

There is far more than this going on in the poem, including the Green Knight's connection with and representation of the force of Nature. John Spiers puts the Frazerian case for the Green Man as a nature deity:

> The Green Knight whose head is chopped off at his own request and who is yet as miraculously or magically alive as ever, bears an unmistakable relation to the Green Man — the Jack-in-the-Green

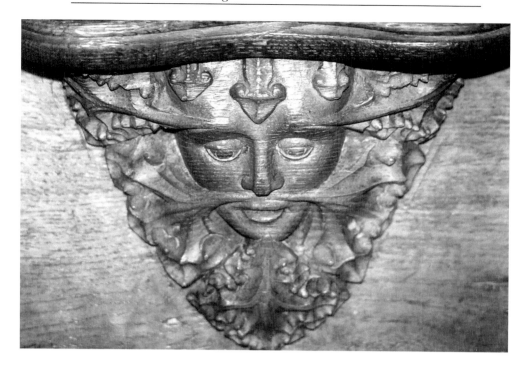

44 *Norfolk, Norwich Cathedral. This fifteenth-century misericord depicts the Green Man with heavy lidded eyes and a foliate beard. His eyebrows and upper lip are sprouting foliage.* Felicity Howlett

or the Wild Man of the village festivals of England and Europe. He is in fact no other than a recrudescence in poetry of the Green Man. Who the Green Man is is well established. He is the descendent of the Vegetation or Nature god of (whatever his local name) almost universal and immemorial tradition whose death and resurrection mythologizes the annual death and re-birth of nature — in the East the dry and rainy seasons, in Europe winter and spring. The episode in which the Green Knight rides into the hall of Arthur's castle among the courtly company at the Christmas feast and demands to have his head chopped off is exactly a Christmas pageant play or interlude — a castle version of the village Folk Play — become real. The central episode of the traditional Folk Play, Sword Dance and Morris Dance was (as Chambers shows) a mock beheading or slaying followed by a revival or restoration to life (often by the Doctor who administered to the corpse the contents of an outsize bottle — the elixir of life).

Spiers goes on to say 'He is no mummer disguised as a Green Knight who rides into the hall; he *is* the Green Knight . . . The "vegetation" aspect of the Green Knight will be immediately recognised. His green beard is like a bush, and together with his long green hair covers his chest and back all round down to his elbows. He carries a holly branch in one hand — "A holyn bobbe/That is grattest in grene when greves arc bare" . . . He is as green as green verdure. It would indeed be singular not to feel that he is an up-cropping in poetry of the old vegetation god.'

Spiers feels the Green Knight to be 'an intruder from a pre-Christian, pre-courtly world'. He also links the famous passage on the passing of the seasons at the beginning of the Second Fitt into his thesis:

> The opening paragraphs of the Second Fitt, superbly conveying an impression of the changing seasons, the revolving year, are not mere decoration. They are integral to the poem; they rise from the core of the unifying seasonal experience. We are not just told that a year has passed; we experience the year changing, the alternating pattern of the seasons.

Thus, John Spiers put the case for the Green Knight as Green Man very fluently 40 years ago. Today we are less certain about the identifying the Green Man and more hesitant about applying Frazer's ideas on comparative mythology. But we find the idea that the Gawain poet is symbolically using a kind of early Mummers Play or Sword Dance attractive. One piece of evidence for this is that Arthur, in trying to comfort Guinevere after the decapitation and revival of the Green Knight, says:

> Dere dame, today dismay yow never,
> Wel becomes such craft upon Cristmasse,
> Laykyng of enterludes, to laghe and to syng,
> Among these kynde caroles of knightes and ladies.
> (ll 470-3)

> (Dear lady, don't be dismayed today;
> such skill well becomes Christmas,
> the playing of interludes, to laugh and to sing
> among these seemly carols of knights and ladies.)

Arthur seems to be here specifically saying that what we have just witnesses is a Christmas game or play for real. The origins of the Mummers Play is a controversial topic these days and beyond the scope of this book. Suffice it to say that the seasonal nature of the plays would suggest a religious or seasonal

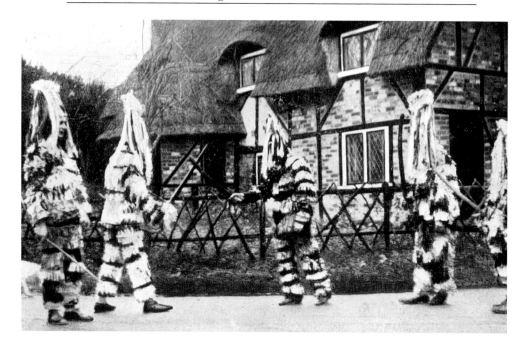

45 The Longparish Mummers, c.1930. George Long

significance (or both), reinforced by the ritualistic nature of the plays, their (for the most part) similar costuming, seasonal repetition and male-only participants. We feel it very likely that some form of folk play acting out a death and revival pattern as sympathetic magic for the turning year was taking place in the fourteenth century, possibly without the text that at some stage evolved around the action. The term 'mummer' was frequently and loosely used in the late medieval and Tudor periods to refer to itinerant or courtly actors, and sometimes to morris dancers. Often miming actors seem to be referred to (eg. 'they be Mummers for naught they say' in the play *Damien and Pythias*) and green clad mummers are recorded in court entertainments. Some scholars have suggested that the latter ribbons of Mummers costumes replaced green leaves or mock green leaves. By the time that the texts are recorded the protagonist who does the killing has become known as St George (possibly a Christianisation) and one wonders if there could be a link between the St George in the English Mummers play (and in other festivals such as a mysterious reference to the saint in the song accompanying the death and revival of the Padstow Hobby Horse on Mayday at Padstow in Cornwall) and the Green George of European customs referred to elsewhere in this book. In Norwich the Guild of St George arranged St George plays in the fifteenth century and the actor playing St George was dressed in a mantle of green satin in 1492.

The Mummers plays recorded over the past 300 years have largely been intended for performance at the Christmas period and so have the Sword Dance Plays of the north-east of England, in Yorkshire, Durham and Northumberland. In most of the Mummers plays from the eighteenth century onwards, death has been by sword fight, but some of the Sword Dance Plays collected by Cecil Sharp in the early twentieth century had (and still have) death by decapitation. The swords of the dancers link into a magical symbol (the pentangle for a five-man team, a Star of David for a six-man team and an octagonal shape for an eight-man team). At Genoside in Yorkshire a six-sided star is locked round the side of the captain, the dancers crying 'a nut, a nut'. They pretend to draw the swords together to decapitate (the swords are in fact locked together), the victim symbolically dying and reviving. In *Sir Gawain and the Green Knight* we also have a decapitation and revival at the same time of year, and much play is made of the pentangle symbol on Gawain's shield which the poet calls 'the endeles knot'. In no other text that we have come across does Gawain use the pentangle as a shield device, save in this poem. The poet seems to have chosen the device for its symbolic value — could an early sword dance have given him the idea?

There are other Midwinter customs connected with greenery such as the bringing in of the evergreens holly and ivy and the January custom of the 'Wilde Mann' of Basle, who sails on a raft down the Rhine, covered in leaves and holding an uprooted fir tree and then heads a celebratory procession through the streets of Basle.

Whether or not the Gawain Poet had seen a Sword Dance or Mummers play, the influence of the cyclical force of nature is strongly present in the poem, which is framed by two New Year scenes and has the highly poetic seasons passage in Fitt Two and Gawain's vividly realistic journey though a British winter landscape, unequalled in literature. The Green Knight functions on several levels — as judge, as God, as the Devil, as a superb host and huntsman, and as a thrall of Morgan the Fay. Perhaps it is as a force or representative of Nature that he links into the folk superstitions of the past and gives us a vivid glimpse of the kind of traditional forces operating on the stone carvers and wood carvers in fourteenth- and fifteenth-century ecclesiastical buildings.

Does Gawain have any symbolic function in the poem? Jessie Weston, whose early twentieth-century book *From Ritual to Romance* explored the Grail legends and influenced T.S. Eliot's *The Waste Land*, thought that Gawain was the original Grail Hero who freed the wasteland and restored the Spring. It is interesting that his Welsh name is Gwalchmei, which means 'Hawk of May', and there is one association of Gawain with Spring in our poem. When he has been dressed in new clothes after his long Winter journey to Bercilak's Castle:

46 *The Tonbridge Mummers performing the Bearsted Mummers Play — the Doctor revives 'Bold Slasher'.* Fran Doel

Sone as he one hent and happed therinne,
That sate on him semely with saylande skyrts,
The ver by his visage verayly hit semed
Welnegh to uch hathel, all on hewes,
Lowande and lovely all his lymmes under
(ll 864-8)

(As soon as he took one and was clothed in it,
one that fitted him well with flowing skirts,
it seemed to each man from his appearance
to be the very spring, with all his limbs
covered in glowing and delightful colours)

It is perhaps going too far to see Gawain symbolically as Spring or Summer displacing Winter, but one of the most powerful elements in the poem is its celebration of the life-force and promise of renewal. On one level, as John Spiers puts it:

The whole poem is, in its very texture — its imagery and rhythm — an assertion of belief in life as contrasted with winter deprivation and death; and it seems finally to discover, within the antagonism between man and nature, between the human and the other-than-human, an internal harmony, even a kind of humorous understanding.

6 The Jack in the Green

In his book *Roof Bosses in Medieval Churches* (1948), C.J.P. Cave discusses possible iconographical links between bosses with foliate heads and 'figures with the lower half hidden in a leafy cylinder or some other shaped covering of foliage'. He cites examples on corbels and bosses at Tewkesbury, Ely and Exeter and goes on to say:

> Many of these figures recall the Jack in the Green which was a familiar figure on May Day in England fifty years ago . . . Jack-in-the-Green was no doubt a survival of pre-Christian tree worship which had filtered down through the Middle Ages even into the nineteenth century. There can be little doubt that in the Middle Ages such survivals of an ancient cult must have been still more numerous. Tree worship was intimately connected with fertility rites, and Jack-in-the-Green and the rites of the May King are generally held to be so connected. It seems therefore that it is quite a possible suggestion that the sprouting faces and kindred figures may have been intended for fertility figures or charms of some sort by their carvers, which might explain why they are often, but not always, put in obscure places, for if they were charms they might hardly have been looked on with approval by authorities imbued with more orthodox ideas. (p67)

A footnote directs the reader to Frazer's *The Golden Bough*. As we have seen in chapter 4, Frazer discusses the evolution of belief in a tree-spirit through examples of European folk customs in which representative green leaf-clad figures symbolise the inter-connection between communities and the seasonal cycle of nature. Frazer makes a direct link between some of these pan-European customs and the English Jack in the Green:

> In England the best-known example of these leaf-clad mummers is the Jack-in-the-Green, a chimney-sweeper who walks encased in a pyramidal framework of wickerwork, which is covered with holly and ivy, and surmounted by a crown of flowers and ribbons. Thus arrayed he dances on May Day at the head of a troop of

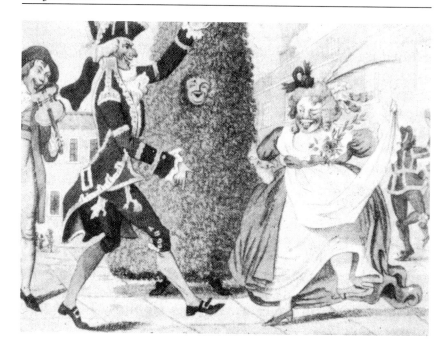

47 *'May Day' or 'Jack in the Green', possibly by Isaac Cruikshank*

chimney-sweeps, who collect pence. In Fricktal (Switzerland) a similar frame of basketwork is called the Whitsuntide Basket. As soon as the trees begin to bud, a spot is chosen in the wood, and here the village lads make the frame with all secrecy, lest others should forestall them. Leafy branches are twined round two hoops, one of which rests on the shoulders of the wearer, the other encircles his calves; holes are made for his eyes and mouth; and a large nosegay crowns the whole. (p129)

Frazer comments that 'Often the leaf-clad person who represents the spirit of vegetation is known as the king or the queen'. The Thuringian May King at Whitsuntide consisted of a man inside 'A frame of wood . . . completely covered with birch boughs . . . surmounted by a crown of birch and flowers' (p129).

The first specific reference we have to the Jack in the Green is in 1795, which is disappointingly late for making a possible connection with the medieval Green Man carvings. However, finding early specific references is a perennial problem with many traditional customs. Either many traditional customs are not so ancient as might be supposed from their context and iconography, or the lack of interest by the intelligentsia in these working class

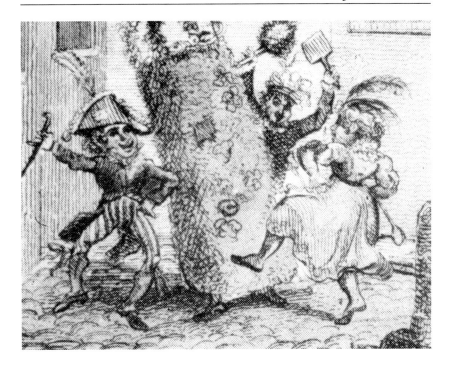

48 'May' from the Illustrated Months of the Year, *1824*

customs before the Romantic Movement at the end of the eighteenth century resulted in them not being documented or mentioned. Sociological research into traditional customs by scholars in the late twentieth century (in reaction to the earlier anthropological studies of customs) has highlighted a surprising level of change and adaptability. Therefore, although the iconography and symbolism of the presentation of the Jack in the Green would be a surprising total invention for the late eighteenth century, we must be cautious of assuming that anything specifically like the Jack in the Green existed in the medieval period. However its antecedents and its emotional and symbolic force may derive from an early period. The name 'Jack' is often given in folklore to early supernatural figures such as Jack Frost, Jack o' Lent, Jack Sprat and Jack the Giant Killer.

The earliest detailed description of the Jack in the Green which has so far come to light is in Strutt's *Sports and Pastimes of the People of England* in 1801 (which in itself assumes a much greater antiquity for the custom than 1795):

> The chimney-sweepers of London have also singled out the first of May for their festival; at which time they parade the streets in companies, disguised in various manners. Their dresses are

usually decorated with gilt paper, and other mock fineries; they
have their shovels and brushes in their hands, which they rattle
one upon the other; and to this rough music they jump about in
imitation of dancing. Some of the larger companies have a fiddler
with them, and a Jack-in-the-Green, as well as a Lord and Lady of
the May, who follow the minstrel with great stateliness, and dance
as occasion requires. The Jack-in-the-Green is a piece of pageantry
consisting of a hollow frame of wood or wicker-work, made in
the form of a sugarloaf, but open at the bottom, and sufficiently
large and high to receive a man. The frame is covered with green
leaves and bunches of flowers interwoven with each other, so that
the man within may be completely concealed, who dances with
his companions, and the populace are mightily pleased with the
oddity of the moving pyramid.

Note that there are a lord and lady of the May (equivalent to the May King
and Queen), in addition to the Jack in the Green, who therefore cannot be
synonymous with the May King, but functions more as a tree representative,
possibly like the maypole. Though perhaps the Jack functions as a composite
man-tree figure.

Strutt's account is similar to the Jack in the Greens today in their revived
forms at Rochester, Hastings and Whitstable. A man is encased in a large
wicker framework stuffed with greenery, the whole often being surmounted
with a crown. The effect is like a walking bush or Green Man, indeed 'Jack in
the Bush' was an alternative name in the early nineteenth century. The Jack
in the Green is specifically associated with the celebrations for the beginning
of Summer and has a retinue including the May King and Queen or lord and
lady (though perhaps he is a part of their retinue) associated with greenery.
In the nineteenth-century accounts the 'Lady' was often played by a man
dressed as a woman, as was often the case with the Maid Marian figure in
the sixteenth-century May Games. Cross-dressing has a fertility significance,
but also it is traditional in folk rituals generally for the women's parts to be
taken by men. Unlike the May King, the Jack is not linked to the May Games,
but specifically to May Day (originally 1 May, but now the early May Bank
Holiday) and a few days either side.

We first hear of (and see illustrated) the Jack in the Green in the
context of working people's celebration of May Day, specifically as the
Chimney-Sweeper's Garland in London. William Hone describes the
custom in London in his *Every Day Book* of 1825 under the title of 'Chimney
Sweepers on May-Day':

49 Whitstable May Celebrations, Kent, with 'Jack in the Green', 1910

> Here is the garland and the lord and lady! . . . Their garland is a
> large cone of holly and ivy framed upon hoops, which gradually
> diminishes in size to an apex, whereon is sometimes a floral
> crown, knots of ribbons, or bunches of flowers; its sides are
> decorated in like manner; and within it is a man who walks wholly
> unseen, and hence the garland has the semblance of a moving
> hillock of evergreens.

A few years later, in 1836, Charles Dickens described the custom in his
Sketches by Boz:

> The man hammered away at the drum, the flageolet squeaked,
> the shovels rattled, the Green rolled about, pitching first on one
> side and then on the other; my lady threw her right foot over her
> left ankle, and her left foot over her right ankle, alternatively; my
> lord ran a few paces forward, and butted at the Green, and then a
> few paces backward upon the toes of the crowd, and then went to
> the right, and then to the left, and then dodged my lady round the
> Green; and finally drew her arm through his, and called upon the
> boys to shout, which they did lustily — for this was the dancing.

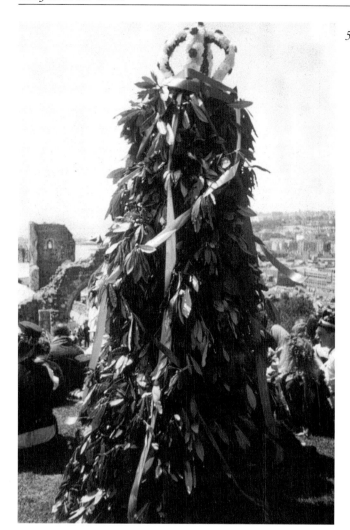

50 *Hastings*
'Jack in
the Green',
Sussex,
1996.
Archie
Turnbull

The economic and social basis for the custom in the nineteenth century was researched by Henry Mayhew and by Adolphe Smith in his *Street Life in London*, who also adds details concerning the construction of the Jack:

> The green . . . was made of large cooper's hoops, joined together by eight poles or standards, as they are called. Glazed calico, garlands of leaves, and rosettes, covered this rough framework. But to dance inside so cumbersome a contrivance is no easy matter. Coal-heavers, or persons accustomed to heavy work, are generally employed; they are stripped of nearly all their clothes, receive unlimited libations of beer, and 3s 6d per day . . . ample receipts are made, though it is in the East End and the poorer

51 Rochester 'Jack in the Green', Kent, 1999. Geoff Doel

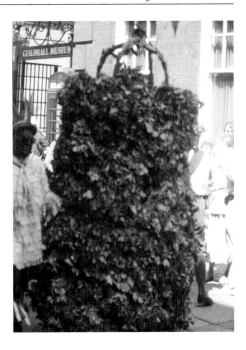

quarters that these street performers meet with the greatest success. Of course, as there is money to be made in this manner, other persons besides sweeps have sent out Jacks-in-the-Green; but such a venture is not altogether safe, for, if found out, the performers run the risk of being mobbed and the green destroyed by those who really belong to the trade.

The Chimney-Sweeping fraternity seem to have been responsible for moving the custom out from London with their expanding businesses in the nineteenth century into southern towns such as Cheltenham, Burford, Orpington, Lewisham, Brighton, Horsham, Bromley, Hastings, Ramsgate, Brighton, Lewes, Farnham, Dorking, Tadworth, Kingston-Upon-Thames and Henfield. The well-known shoemaker, folksinger and bell-ringer Henry Burstow recalled the Jacks at Horsham in the mid-nineteenth century in his *Reminiscences of Horsham* (1911):

> May Day, or Garland Day, was a very jolly time for us youngsters, not only because it was a holiday, but also because we used to pick up what seemed to us quite a bit of money. Early in the morning we would get up our best nosegays and garlands, some mounted on poles and visit the private residents and tradespeople. We represented a well-recognised institution, and invariably got well received and patronised . . . On this day, too, we had

Jacks-in-the-Green. The chimney sweeps used to dress up in fancy costumes and in evergreens and flowers, and accompanied by a fiddler or two, parade and dance all round the town and neighbourhood. There were two sets of Jacks-in-the-Green when I was a boy (*c*.1850), the Potter and the Whiting parties, and considerable rivalry existed between them.

Currently there are three major revival Jack in the Green customs in the south-east, all centred on the early May bank holiday, and all where documented former customs are known. The Whitstable May Day procession before the First World War featured a Jack in the Green, and this was revived in the 1970s. The author Russell Thorndike remembered the custom at Rochester during his boyhood there in the 1890s. This has been revived by Gordon Newton and the Motley Morris in a spectacular three-day event featuring nearly one hundred Morris sides and culminating in a grand procession on the Bank Holiday Monday headed by the chunky, evergreen, crowned Jack in the Green who was 'aroused from his Winter sleep' at sunrise on the first of May.

The Hastings customs has been well documented and well researched and revived by Keith Leech and Mad Jack's Morris, also over the early May Bank Holiday weekend. Press records of the custom range from 1848 until 1913. An early photograph survives which may date back to the 1860s, and this shows several leaf-clad figures, a feature which has continued in the revival, which emphasises iconographical connections with the Green Man (there are four Green Man church carvings in Hastings). The Hastings Jack is slimmer than his counterpart at Rochester and an account of 1880 mentions the Jack in the company of Morris Dancers at nearby St Leonards.

In Hastings the custom seemed to be in decline from the 1870s. The *Hastings and St Leonards Observer* commented in May 1883:

> Well, I hardly know whether to ask the reader to lament or rejoice with me over the demise. Human nature is weak. 'Jack' and his 'mates' played strange antics occasionally, and the 'Green' not infrequently came to grief. I think the party which distinguished itself a year or two ago by making an unwilling and inglorious entry into a plumber's shop plate-glass window in South Terrace, was sober, but the ancient May custom of honouring the goddess Flora and which, in some strange way the sweeps succeeded in almost claiming a monopoly of, is dying.

An unusual aspect of the revival at Hastings is the 'killing' of the Jack at the end of the festival. The influence for this was descriptions of similar events in Germany and France in Frazer's *The Golden Bough*, though there is no documentary evidence for this happening in England. After several bad summers it was decided to revive the Jack after killing him, since when the weather has improved!

It is possible that the Jack in the Green developed as an alternative to the Maypole as an emblem of regeneration when the Maypole was banned by the Puritans in the 1640s. The Jack in the Green is first documented as the Chimney Sweeper's Garland, which links it in to a tradition of workers celebrating the first of May by the use of Garlands in some way connected with their occupations. The Milkmaids' garlands were famous in the eighteenth century — these developed from flowers into pewter ware associated with the trade and carried by boyfriends whilst the milkmaids danced, often to their customers. Shepherds in Sussex used to garland their sheep, and at Brighton, Abbotsbury and other villages along the Dorset Chesil Beach the opening of the mackerel fishing season in May was celebrated by fishing boats carrying out garlands of flowers to through into the sea to encourage the mackerel 'crop'. The Sussex antiquarian Sawyer, writing of May Day 1883 says:

> This day is known in Sussex as Garland Day, and is a favourite day with the Brighton fishermen for commencing mackerel fishing. When the fishermen start on this day, they decorate the masts of their boats with 'garlands', while at other times they used to accompany the sweeps in their celebration of the day.

This shows cooperation between the different traders and a possible link between the Chimney Sweepers' celebrations at Brighton (which presumably featured a Jack in the Green) and those of the fishermen.

At Abbotsbury the custom ended up on 13 May, probably due to the calendar changes of 1752. The Edwardian Member of Parliament and pioneer photographer and folklorist Sir Benjamin Stone photographed the custom and left us this account:

> On the 13th May, locally known as 'Garland Day', the children go round the village with large garlands of flowers, soliciting gifts of money from householders. After they have called on all the inhabitants they proceed to the beach. Then the garlands are placed in boats, taken out to sea, and, instead of being committed to the waves, as they used to be, and as such tributes are still in several of the Greek islands, brought back again. This is a recent

52 Garland Day at Abbotsbury, Dorset, nineteenth-century. Sir Benjamin Stone

innovation. So also is the ecclesiastical character now given to the festival — the children taking the garlands to church — where a special service is held — before they are carried out to sea in the boats.

It is, indeed, dying out. Of old a dozen or more boats, each with a garland, put off from the shore at Abbotsbury, as against one from Swyre and another from Puncknowle (local villages also just off the Chesil), and every floral offering was placed on the waves in the firm belief that it would bring luck to the mackerel fishing. But latterly only two or three boats have gone to sea.

While, however, the ceremony is almost a thing of the past, Garland Day is still observed as a general holiday by the inhabitants, who dress in their best and provide bounteously for visitors from neighbouring villages.

For May Day celebrations, including those displaced in the calendar for various reasons to later parts of May, represented one of the few important secular celebrations in the calendar. However, the origins of the May celebrations may well date back to religious observations in earlier cultures including the Celtic Beltane celebrations. At Abbotsbury the church detected a possible pagan survival or superstition in the surrendering of the garlands to

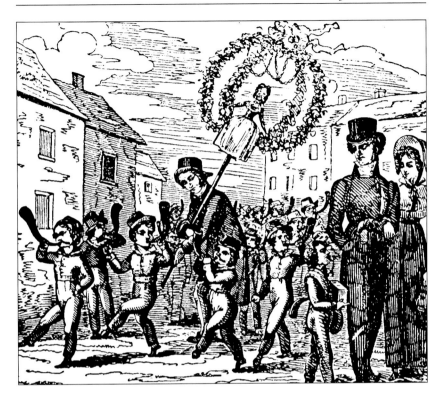

53 Children with Cow Horns parading the May Garland at King's Lynn, Norfolk, c.1820

the waves and Christianised the whole ceremony — helping, it must be said, its survival by religious and 'establishment' sanction. When the custom was once more under threat officialdom helped once more to save it in the form of a new village policeman who reprimanded local children for begging. The resultant publicity and apology, including the donation of a police garland the following year and the turnout of parents in support of their children, saved the custom for several more years, though as we write there is once more talk of ending the custom, which would be a tragic loss to the community. Such is the strength of the superstition that we were informed that one extra garland was still being unofficially donated to the sea each year in the 1990s.

In many villages and towns in the south of England (the area where the Jack in the Green was also popular), and the Midlands and eastern counties, the custom was for children to carry May garlands from door-to-door, often with a May doll inside the garland, and beg for sweets or money. It was a good luck ritual and represented (as with the maypole and the Jack in the Green) the bringing in of Summer, though it was unlucky for the flowers to

be brought indoors. Thomas Trowsdale described the custom on 'Garland Day' in Sevenoaks in Kent in 1880:

> This morning I had the pleasure of witnessing a lingering remnant of the olden observances of 'Merrie May-day'. Numbers of children went about from house to house in the Sevenoaks district in groups, each provided with tasteful little constructions which they called May-boughs and garlands. The former were small branches of fruit and other early blossoming trees secured to the end of short sticks, and were carried perpendicularly. One of these was borne by each of the children. Two in every group carried between them, suspended from a stick, the 'May-garland', formed of two transverse willow hoops, decorated with a profusion of primrose and other flowers, and fresh green foliage . . . At every door the children halted and sang their May-day carol, in expectation of a small pecuniary reward from the occupants of the house.
>
> Middle-aged matrons, who have resided in this part of the 'garden of England' all their lives, speak in terms of pardonable pride of the immense garlands of their girlhood. Forty years ago, I am told, the May-garlands often exceeded a yard in diameter, and were constructed in a most elaborate manner.

Clearly it was important to symbolise the arrival of Summer in some appropriate way involving greenery and flowers. The great surviving May Festivals at Padstow and Helston in Cornwall traditionally have greenery and flowers brought into the community as an important aspect of the rituals. But the Jack in the Green is distinct in having a composite humanoid-tree figure at the centre of the celebrations. Could this figure be linked to the foliate carvings in hundreds of British cathedrals and churches? The connection is certainly made today in the successful revivals of the Jack in the Green customs at Hastings and Rochester. The Hastings custom is now called 'The Green Man Festival' and extends from Friday evening to Monday — the best time to see the Jack is in the Monday morning parade and in the afternoon at Hastings Castle, where he presides over a display of morris dancing. Some years ago William Anderson gave a lecture on 'The Green Man' at the Rochester custom soon after his book came out and this event is also now a long weekend festival closely associated with morris dancing, with a procession headed by the Jack in the Green on the Monday afternoon.

7 The Man in the Oak

In 1584 an enlightened Kent graduate thinker Reginald Scot wrote a very influential book called *The Discoverie of Witchcraft* in an attempt to disprove the existence of witchcraft both as an organised and subversive 'religion' and as a supernatural agency which could be harmful. His aim was to cease the relentless persecution of witches and to thereby save innocent lives. In this he was eventually successful because although his work was proscribed by King James VI of Scotland (who wrote his *Daemonologie* to refute it and then had it burnt by the public hangman when he had become King of England), the views of he and his successors prevailed at last even over the King himself.

Reginald Scot lists a range of superstitious figures which were generally believed in during his boyhood, but at the time of writing are no longer generally credited, his point being that witchcraft and witches would similarly soon no longer be believed in as man advanced in learning. Among the lengthy list are: Robin Goodfellow, the wodewose (wild man of the woods) and 'the man in the oak' — it is perhaps significant for our thesis that these three figures are seen as distinct in the sixteenth century. Could this 'man in the oak' belief link in with the medieval carvings of Green Men and/or with the Green Knight featured in the poem *Sir Gawain and the Green Knight*?

Men in the Oak together with Robin Goodfellows and Jack in the Wads appear in the nineteenth-century *Denham Tracts*, but the list is taken at least at one remove from Scot's original list. Is there any other written evidence for 'oak men'? Katharine Briggs, in *A Dictionary of Fairies*, has a section under 'Oakmen': 'There are scattered references to oakmen in the North of England, though very few folktales about them'. She does refer to Ruth Tongues' traditionally based story *The Vixen and the Oakmen* from Cumberland and the rhyming proverb 'fairy folks are in old oaks'. Francis Kilvert has a poetical passage in his Diary about the oak men of Moccas Park, Abergavenny:

> I fear those grey old men of Moccas, those grey, gnarled,
> low-browed, knock-kneed, bowed, bent, huge, strange,
> long-armed, deformed, hunchbacked, misshapen oak men that
> stand waiting and watching century after century biding God's
> time with both feet in the grave and yet tiring down and seeing

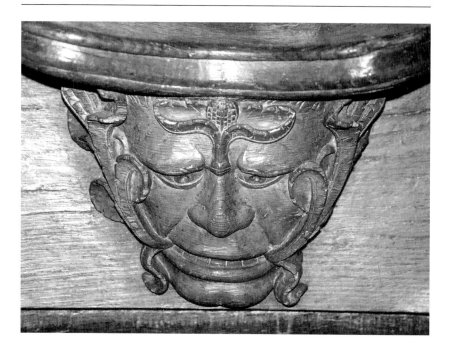

54 Norfolk, Norwich Cathedral. Fifteenth-century misericord. With a pained expression and a furrowed brow, this suffering Green Man has to endure leaves growing from his mouth. Felicity Howlett

out generation after generation, with such tales to tell, as when they whisper them to each other in the midsummer nights, make the silver birches weep and the poplars and aspens shiver and the long ears of the hares and rabbits stand on end. No human hand set those oaks. They are 'the trees which the Lord hath planted'. They look as if they had been at the beginning and making of the world, and they will probably see its end.

The oak tree was of course sacred to both the Celtic and Germanic early cultures in the British Isles. The name of the priestly caste of the Celts, the Druids, means 'oak knowledge' and classical sources describe the use of the oak tree in ceremonies and sacred groves by the Celts. The oak tree was also sacred to the Anglo-Saxons and associated with their god Thunor.

The oak was also a regal tree, and a clue to the significance of Reginald Scot's reference to the 'man in the oke' may be found in the way that popular culture and superstition dealt with and interpreted the decapitation of Charles I and the succession of his son after hiding in an oak tree. There are many pubs called *The Royal Oak*, the inn sign often representing the head of

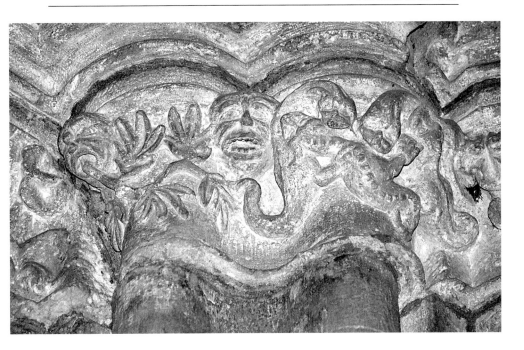

55 Orkney, St Magnus Cathedral, Kirkwall. Capital of pillar in east end showing Green Man and lizards. From a photo in the possession of Liz Johnston, Assistant Custodian, St Magnus Cathedral

either Charles I or Charles II inside the branches of an oak tree, sometimes associated with a crown. It was Charles I who was decapitated, and his son and successor Charles II who hid in the oak tree — somehow the fate of the two blended together in legend, as several later collectors of folklore found when they questioned rural people about traditions concerning the Stuart monarchs. Could it be that by coincidence the two Charles acted out a myth connected with the 'man in the oke', a myth of regeneration symbolised by a connection between man, even perhaps king and oak tree? And does the iconographical perception of the fates of the two Charles' as a disembodied head in the branches of an oak tree link up with the images of the disembodied head disgorging leaves, carved in churches in stone and wood?

Charles II's adventure in the oak tree occurred after his defeat at the Battle of Worcester in 1651. Charles sought refuge at Boscobel House, then a remote hunting lodge. He hid for a day in the branches of an old oak tree in Boscobel Forest and then at night entered the house and hid in the attic. He escaped to the Continent and returned to England to effect the Restoration in 1660, timing his triumphal entry into London on his birthday — 29 May. Samuel Pepys records in his diary how he was told 'how the people of Deale

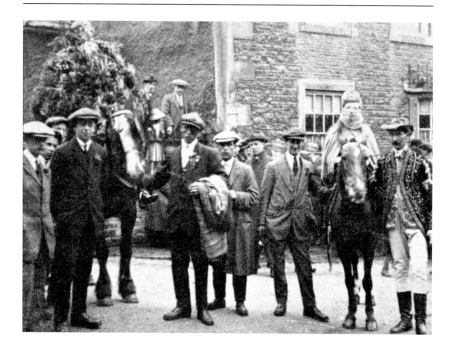

56 The Castleton Garland c.1930. Note the consort played by a man

(Deal in Kent) have set up two or three Maypoles and have hung up their flags upon the top of them' to welcome the King on his return.

The date of the King's return was celebrated for a long time as a public holiday with a special church service, and because Charles hiding in the oak tree had particularly captured the imagination, 29 May was called 'Oak Apple Day'. The day was also celebrated by the wearing or carrying of bunches of oak leaves, often containing the growths called 'oak apples'. Charles Kightly in *The Customs and Ceremonies of Britain* suggests that 'they may also have perpetuated a far older pagan festival honouring the most sacred of trees'.

Many new customs were started up as part of the celebrations for this day, and some of the older May Day festivities which had been banned by the Puritans were started again but transferred to 29 May in honour of the 'Merry Monarch'.

The most celebrated of these customs is the Castleton Garland Custom in the Peak District. This could be a new coinage for the Oak Apple Day celebrations, because the King and the Lady (and in earlier times some of their attendants) wore Stuart costumes and until 1896 the procession contained morris dancers who waved sprays of oak as they danced. However, the appearance of a King and Lady parallel other older May celebrations, including the nearby Winster Morris Dancers, who feature a King and

57 Making the Garland on Oak Apple Day, 1985. Geoff Doel

Queen amongst their attendants. The maypole and morris dancers (the latter discontinued after 1896) are also older features of May celebrations, though they could have been adopted by a new custom. The garland which encompasses the King is a unique feature, being made of flowers today, though in its earlier form there was more greenery included and thereby a closer link with the Jack in the Green custom, providing some circumstantial evidence that the custom of the Jack in the Green is likely to pre-date its first recorded mention of 1795.

The first reference to the Castleton Garland is in the Churchwarden's Accounts for 1749 when 8d was paid 'for an iron rod to hang ye Ringes Garland in'. The church bell ringers organised the custom for most of the nineteenth century, but handed over the organisation of the event to a Garland Committee round about 1897, although many of the bell ringers and their families still retained a close connection with the event. There were substantial changes to the custom about the year 1900. Previously morris dancers had been a part of the procession and waved sprigs of oak, but these were succeeded by school girls. A maypole and maypole dancing and Stuart costume for the King, the Lady and some of the other riders were introduced. Early photos show a number of riders in Stuart costume, but nowadays only the King and the Lady ride horses; originally the horses were local farm horses, but nowadays they are specially brought in. It is thought that the morris dancers were similar in style to the famous nearby Winster morris dancers, whose tradition was collected by Cecil Sharp just before the

58 The Castleton Garland being placed over the 'King', 1985. Geoff Doel

First World War, and who are still going strong and are still associated with a May King and Queen, which perhaps correspond to the King and his Lady at Castleton, where the term queen is reserved for the top knot or posy of the garland, which is placed on the war memorial at the end of the ceremony; it used to be given to a local dignatory who helped to sponsor the custom before the First World War.

The names of the Garland Kings are known in detail since Thomas Hall (King from 1875-1913), the name of one earlier King, George Watts some time before 1870, is known. Traditionally the role of the Lady or Consort was taken by a man, as seems to have generally been the case with the Maid Marion tradition in the May Games in England and Scotland in the sixteenth century. Bill Eyre is the earliest recorded consort; pre-1877, the Eyre family used to make the 'Queen' or topknot. Photos survive of Arthur Whittingham, the Lady from 1896-1900; the last man to act as the Lady was Tommy Liversidge from 1928-55. He was replaced by a lady Jean Abbott, an accomplished horsewoman whose father supplied the horses and led her, from 1956-65, as it was difficult to find a man who could ride side-saddle. The tradition of having a local beauty rather than a man to play the part of the Lady has continued.

We have attended the Castleton Garland day about six times in the last twenty years and have found it be one of the most interesting and friendly of British traditional customs. It is worth coming for the whole day, for in the

morning you can watch the garland being made in an outbuilding attached to one of the local pubs. The frame of the garland is the rim of a bicycle wheel, built up to a beehive-shaped apex by metal strips and netting, to which the flowers are attached by pieces of string, so it is a painstaking business performed by a team of men while the ladies work on the 'Queen' or topknot. Large quantities of wild and cultivated flowers are donated or purchased, and the balance of colours in the garland each year varies. Early accounts suggest that there was more greenery in the garland in the nineteenth century, but nowadays it is largely floral. The early accounts suggest that the frame of the garland was originally wooden or of lead (Castleton being in a lead-mining area).

In mid-afternoon the local policeman erects the maypole in the square and then the two shire horses arrive, which are nowadays hired for the evening. At 5.45pm the Beating of the Bounds takes place, where the Garland King and his Lady ride in their Tudor costumes round many of the attractive back streets and by-lanes of Castleton which will not be featured in the more prominent procession in the evening. Many of the older citizens stand at their doors or gates wearing sprigs of oak, which is the traditional emblem of royalist support on Oak Apple Day. Oak is nowadays hard to find near Castleton and is sold by vendors for the evening procession (just as it used to be sold by vendors in London on Oak Apple Day in the eighteenth and nineteenth centuries).

The Beating of the Bounds ends in time for the main procession, which starts at 6.30pm from one of the local pubs, who take it in turn to host the custom. The King waits on horseback for the heavy Garland in its frame (about half a hundredweight) to be carried to him and then lowered from a wall to envelop him. The King's horse is then led in the procession followed immediately by the Queen and accompanied by a spirited brass band and girl dancers dressed in white. The procession halts at every pub to be 'whetted', that is to receive free drinks, and whilst it is stationary the band plays tunes and the girls dance. The local wolf cubs protect the girl dancers by an oblong of held sticks, so a number of the local communities are involved.

At about 8pm the topknot is taken off the top of the Garland, and the remainder of the Garland is hoisted up the church tower and displayed for a week on one of the pinnacles of the tower, all the other pinnacles being decorated with sycamore. The King then walks through a file of the girls and laces the topknot in front of the War Memorial, which he salutes to the accompaniment of 'the Last Post'. The evening concludes with the girls doing ribbon-dancing round the maypole to country dance tunes played by the band.

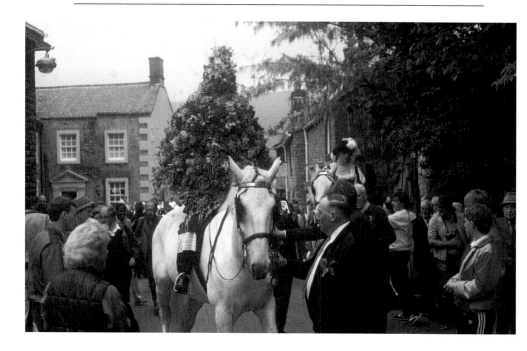

59 The Castleton Garland. The 'King' and his 'Consort' are escorted round the town, 1987. Geoff Doel

The amount of changes to the Castleton Garland custom over the past hundred or so years alerts us to the dangers of assuming that folk customs are static and unchanging and highlights the problems in trying to speculate on the nature of the largely undocumented rural traditions of the Middle Ages. Yet many of the essential emblematic features of this custom do seem to have survived the modern changes (the main casualty being the cross-dressing of the 'Lady'), so perhaps have their roots in some pre-Reformation May ceremony, before being given new impetus in a celebration of the returning monarchy.

8 The Burry Man

Ritualistic acts within a community which have been performed over a very long period of time, and which through some quirk of fate have survived floods, wars, plagues and political interference (not forgetting the Industrial Revolution) to have a continuing presence in the twenty-first century, do not merit to be regarded as some kind of quaint anachronism. They are as flies in amber, of intrinsic interest in themselves, and the more precious because they are fragile. There is a question mark about their survival in an age which tends to be unappreciative or dismissive of community identity and of ritualised actions, which, because they are not readily understood, are regarded as pointless.

One of the most arresting Green Man rituals — and he is called on this occasion the Burry Man for his costume is composed almost entirely of a common hedgerow weed, the burr — comes not from England but from north of the Border, from the town of South Queensferry on the south bank of the Firth of Forth, some eight miles from Edinburgh. In the past the Forth/Clyde line was a buffer frontier area in which 'separateness' and local identity was always the more consciously and keenly felt. South Queensferry was geographically the gateway to the southern kingdoms for the onetime Pictish kingdom of Fife and the eastern highlands, and is thought to have derived its name for services rendered to Saint Margaret the saintly wife of Duncan Canmore in the eleventh century. Now the great Forth Bridge sweeps high over the town connecting the two shore lines and the town has gone into tourism, providing pleasure trips round the Forth with stops on some of the islands which picturesquely dot what is in fact a great fjord.

The ritual connected with the Burry Man is similar to that of others known to have been performed in two other Scottish east coast fishing communities, Fraserbugh and Buckie, with slight and possibly unimportant variations. It takes place on the second Friday in August and precedes the Ferry Fair, which the Burry Man opens at 6pm outside the Hawes Inn. The Ferry Fair Committee elect the Burry Man, who is supposed to be a local. The Ferry Fair was formerly a Lammas Fair, and some scholars suggest a relation to the Celtic festival of Lughnasadh and though this festival survives in an accepted Christianised form in Ireland, there it is related to bonfires, music and dance. Others see in the Burry Man ritual a different kind of

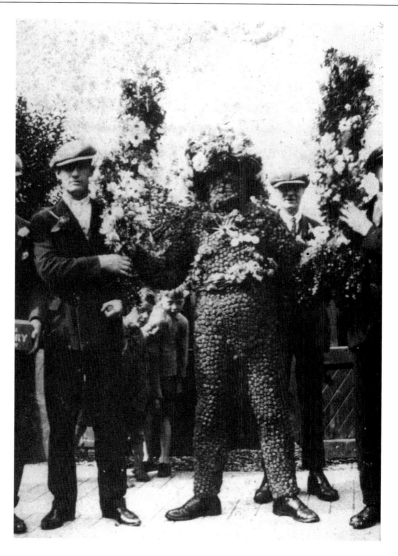

60 The Burry Man, South Queensferry. Archival

harvest festival in which the fruits of the sea, as well as the fruits of the land, and indeed the health of the people, are being safeguarded through propitious rites. Another interpretation, though this is no longer fashionable and often open to attack, is that of the British anthropologist Sir James Frazer, who suggests that such rituals are in essence sacrificial, whether symbolic or real, and that the Burry Man is a type of scapegoat figure who might in antiquity have been selected and sacrificed on behalf of the community as a way of ensuring good harvests. Few would accept nowadays that the religious origin

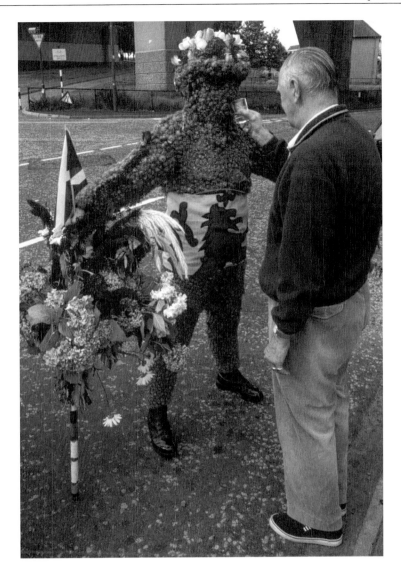

61 *The Burry Man drinking whiskey through a straw, South Queensferry, 1994.*
Geoff Doel

of the custom should be sought for. The modern approach is to examine the ritual as an 'adaptive response to the social and physical environment'.

If the ritualistic purpose of the custom has been forgotten, one might ask the question what is the purpose of keeping the custom going? Particularly when the Burry Man himself must endure extreme physical discomfort for the better part of a day and when numbers of others must be involved,

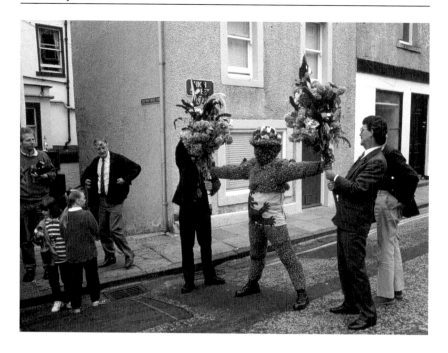

62 *The Burry Man, South Queensferry, 1994.* Geoff Doel

without payment, in preparations which last over a number of days. There is, in fact, a local desire to keep the custom as an expression of the will of the community, and a communal belief, superstitious or not, which sees the Burry Man as a highly symbolic bringer of good luck to the local area and to its people. The addition of the Scottish flag to the Burry Man's costume in recent years must be seen to have cultural significance and is part of the evolution of a newly re-emerging Scottish identity.

The Burry Man's day begins early — almost at first light, in order to present himself at 7am at a room which has been designated for the dressing ceremony. Nowadays it is in one of the many public houses which line the high street. The room is filled and has been so for a few days, with thousands of the spiky seed cases of the burdock plant, the 'burrs' which have been gathered days before and prepared by being picked over and dried out and laid on squares of paper ready to create this Green Man. A few helpers (always male in the past, for this is male-orientated ritual), begin to 'dress' the Burry Man by pressing the paper squares holding the burrs against his clothing, working from the ankles upwards. The burrs adhere naturally by means of their sticky spikes. Dressing will take the better part of two hours. The Burry Man stands in his ordinary clothing, legs wide apart and arms stretched out. When the burrs reach his shoulders, a balaclava of a dark colour is placed over

the Burry Man's head and topped with a bowler hat over which netting has been stretched, surmounted by a wreath roses and one red dahlia. The neck and face (though not the eyes of the Burry Man) is covered in burrs, the hat now adorned with roses. One or two roses are added to the shoulders of the costume, the Scots flag is wound round the waist, a floral staff is put into each of the Burry Man's hands and at nine o'clock a living but silent Green Man is ready to begin his perambulations through South Queensferry, a town which spills down a steep hillside to the banks of the Forth.

The Burry Man is proceeded by a boy or man with a bell, the evident function being to alert the community to his coming, and has two important helpers with whom he processes and who are responsible for guiding him through the nine miles of streets and narrow 'wynds' (a Scots word for a passageway or lane) and repairing his costume if required. In the past these helpers wore a costume which effectively disguised their identity. As the day progresses the Burry Man will begin to sweat heavily around the head and face and will soon hardly be able to see, the burrs will work their way through his clothing and cause discomfort, there will be additional discomfort because of his stance for he cannot bring his legs together or drop his arms, and he will begin to be dehydrated. He cannot take cooling drinks because he cannot be permitted to urinate so he is offered instead the Scottish cure-all, whisky, but only through a straw. Little nips of Scottish whisky will keep him going throughout the day and there will be some respite when he is propped up against a wall or simply allowed to stand between his two staves while his helpers take a money collection — traditionally a 'penny' — in a can.

When the sun begins to lose its strength in the early evening and all the community has been touched by the Burry Man's presence, his long day is over and he is returned to his beginning, to his robing room in the public house where the burrs are unceremoniously torn off and where he is relieved of his dress and role. There are few who are not in some ways moved by his highly symbolic green presence on Burry Man Day. Whatever the weather, the ritual generates good will and a sense of the continuity of the community, and it is perhaps significant that the day is one in which the Burry Man as Green Man has sought out the local people in their own homes — they do not seek him out, and he has been identified by his perambulation of the boundaries of their community. Whatever he represented in the dim and distant past, whether god or sacrificial victim, today he is regarded as the embodiment of good luck for the town and was traditionally regarded as carrying away the ills of the community, for which he was paid. His responsibility is a heavy one, for had his willpower, strength and courage failed at any point, one feels that the ritualistic intent would have been nullified, hence it may be important to recognise that there is something selfless and even heroic about his efforts.

The Buckie and Fraserburgh customs further up the Scottish east coast were associated with the herring fishing. At Buckie, if the herring fishing was unsuccessful, a man was wheeled in a barrow through the community; like the Burry Man he was a flannel shirt covered with burrs. Similarly at Fraserburgh until the mid-nineteenth century one of the fishermen was chosen to 'raise the herring', and ride on horseback through the streets preceded by a piper and followed by a crowd. He wore garments covered in burrs and a hat attached with herrings hanging head down from the brim.

Sir James Frazer in *The Golden Bough* drew attention to a number of folk rituals in France and Germany which have parallels with the Burry Man. One of the most illuminating is the Bavarian Whitsuntide custom of the Pfingstl:

> At Niederporing, in Lower Bavaria, the Whitsuntide representative of the tree-spirit — the Pfingstl as he was called — was clad from top to toe in leaves and flowers. On his head he wore a high pointed cap, the ends of which rested on his shoulders, only two holes being left in it for his eyes. The cap was covered with water-flowers and surmounted with a nosegay of peonies. The sleeves of his coat were also made of water-plants and the rest of his body was enveloped in alder and hazel leaves. On each side of him marched a boy holding up one of the Pfingstl's arms. These two boys carried drawn swords. They stopped at every house where they hoped to receive a present; and the people, in hiding, soused the leaf-clad boy with water. All rejoiced when he was well drenched. Finally he waded into the brook up to his middle; whereupon one of the boys pretended to cut off his head. (p229)

There are a number of parallels between the two customs. Both have figures covered in greenery, both wear masks of greenery with eye-slits, both have flowers on their crowns, both are helped by two attendants who support the arms of the scapegoat figure, and in both customs there is a perambulation involving the collection of money or gifts from householders or bystanders. The Pfingstl differs from the Burry Man in being sacrificed, though they both undergo discomfort on behalf of their communities. The sacrifice of the Pfingstl as a scapegoat is however paralleled in another British folk custom, the Hunting of the Earl of Rone at Combe Martin in Devon.

The Hunting of the Earl of Rone was an Ascension Day custom (the Pfingstl being a Whitsun custom), banned after 1837 and accurately and interestingly revived in 1978 by Tom and Barbara Brown on the late May bank holiday. A nineteenth-century account of the customs mentions the

63 Orkney, St Magnus Cathedral, Kirkwall. Drawing of a Green Man on the back of an ancient wooden chair now in the Minister's Vestry. Drawing by Liz Johnston, Assistant Custodian, St Magnus Cathedral

masked Earl of Rone (possibly a folklore memory of the fugitive Earl of Tyrone) hiding in Lady's Wood, where he was discovered by Grenadiers:

> They immediately fire a volley, lay hold of their prisoner, set him on the Donkey with his face towards the animal's tail, and thus conduct him in triumph to the village. Here the Hobby-Horse and the Fool, and great numbers of the inhabitants, join in the procession.
>
> At certain stations in the village the Grenadiers fire a volley, when the Earl falls from his Donkey apparently mortally wounded. Hereupon there is great exultation on the part of the soldiers, and excessive lamentation on the part of the Hobby-Horse and the Fool. After great exertion the latter invariably succeeds in healing the Earl of his wounds, and then the procession re-forms and marches onwards once more.

At every public house there is also a stoppage for purposes of refreshment . . . Moreover there are further innumerable delays, caused by the perpetual efforts of the performers to levy additional contributions from the visitors who throng the street. As a general rule small sums are given readily, for in case of refusal the Fool dips the besom which he carries in the nearest gutter and plentifully besprinkles the rash recusant, and should not this hint be promptly taken the Hobby-Horse proceeds to lay hold the victim's clothes with his 'mapper', and thus detains his prisoner till the required blackmail is forthcoming.

About night-fall the procession reaches the sea; and the proceedings are thus brought to a close.

There is a fascinating blend of historical pageant overlaying something seasonal and more ancient about this custom. Scapegoat/sacrificial elements are particularly strong in this custom, paralleling the Pfingstl. Other similarities are the offerings and the sprinkling with water. The timing of these two customs suggest a connection with the celebration of the burgeoning of Summer.

The two attendants with drawn swords in the Pfingstl custom are paralleled in a Welsh May custom, which was specifically connected with a King of Summer. In the Breconshire parish of Defynnog in the 1840s, there is an account of two men with drawn swords walking in front of the King of Summer, a boy decked with birchen boughs and wearing a crown of ribbons, who was carried by his attendant. He was followed by a King of Winter and a crowd of followers, and the group received donations and food and drink as they processed through the community. An image decked with greenery is recorded in May festivals in Thuringia (Eastern Germany) until the 1950s and at Rutten in Belgium a man decked in ivy leaves appears in the May festival.

9 The Green Man and the arts today

In this chapter we wish to explore the impact of interest in the concept of the Green Man in modern literature, art, opera, film and television, in part to test William Anderson's theory of the awakening of the 'sleeping archetype' (see chapter 1), and in part to see whether a coherent view of the Green Man has developed in twentieth-century culture. Ideas about the Green Man in culture of necessity post-date the coinage of the term by Lady Raglan and Cave, but although Sir James Frazer did not use the term Green Man in *The Golden Bough*, his comparative mythological and folklore approach drew attention to possible links between ancient and surviving rituals and gave a religious perspective to seasonal customs. This was an important influence on culture — an example being the effect of anthropological myth on T.S. Eliot's enormously powerful poem *The Waste Land*. Perhaps equally important in cultural terms was Jung's emphasis on the connection between symbols and the subconscious mind. Again, though Jung did not mention the Green Man, his ideas and methods can usefully be employed in tracing the cultural significance of the Green Man's popularity, as William Anderson has shown in his book.

Some twentieth-century literature with affinities to the Green Man has developed simply from fascination with early literary treatments, rather than from the influence of anthropology, psychology or ecclesiastical carvings. W.B. Yeats' play *The Green Helmet* (1910) was partly based on *Bricrui's Feast*, one of the apparent sources of *Sir Gawain and the Green Knight* (see chapter 5). Iris Murdoch's novel *The Green Knight* was loosely based on *Sir Gawain and the Green Knight*; it seemed unaware of the new forces of interest in the Green Man which had been unleashed, though it had a sensitivity to the themes and conflicts in the medieval poem. The mysterious Peter, who has a green umbrella, is 'identified' by several of the characters as the Green Knight, and the hero Clement wrestles to find parallels between the Green Knight story and the events of the novel: 'Pieces of the story are there, but aren't they somehow jumbled up and all the wrong way round?', Clement concludes. Iris Murdoch's *The Green Knight* is intellectually ingenious, but seems to lack

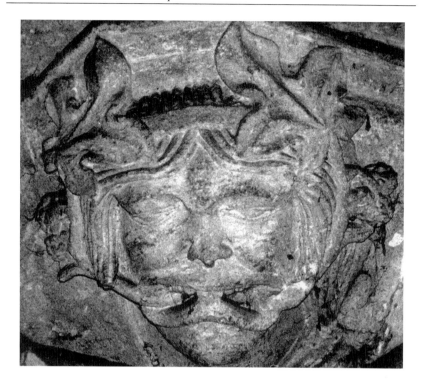

64 Oxfordshire, Dorchester Abbey. Thirteenth-century capital. The Green Man has a distinctive hairstyle, centre parted and swept over each ear on either side of the face. The clasped teeth meet only in the centre of the mouth for the sides of the mouth are forced apart by thick branches. Felicity Howlett

the power, the compassion, the humour and the symbolic significance of the original medieval work.

We have seen (in chapter 1) how environmental groups such as the Green Party and Common Ground have developed a benign concept of the Green Man, who will 'walk with us through what seems to be very difficult times' as Susan Clifford put it in the excellent *Omnibus* television documentary 'The Return of the Green Man'. The artist John Piper shared this view, saying on the same documentary that 'I thought it was a very nice thing to discover because nobody else seems to trouble with it . . . I think they're very nice and friendly'. Piper did dozens of paintings and sketches and ceramics of heads disgorging vegetation using different colour schemes at the end of his career. He also portrayed Green Men in stained glass (a medium in which the Green Man is rarely found in the Middle Ages) with Patrick Reyntiens at the Wessex Hotel in Winchester, a city with traditions of Green Men carvings in its cathedral, public school and at St Cross

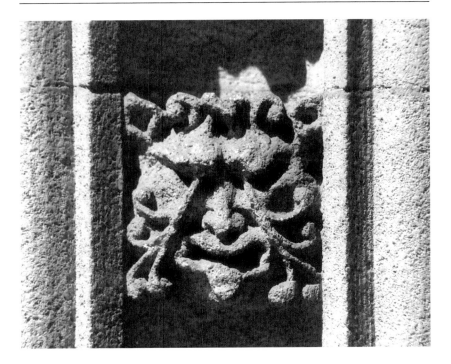

65 *Oxfordshire, Brasenose College, Oxford. Eroded sandstone exterior stone carving. Highly stylised representation of the Green Man with animal-like ears and portrayed as a grimacing death head, and with thick branches protruding from his empty eye sockets.* Felicity Howlett

Church. Some of John Piper's Green Man work is shown in the book *John Piper — a Painter's Camera*.

Artist and sculptor Joseph Beuys (1921-86) became interested in the subject earlier in his career and connected it to social and political ideology. Primarily a sculptor, Beuys was a founder of the German Green Party, and was inspired by myth, nature and the energies of the natural world. His main theme was renewal and this was particularly exemplified by his planting of the 7000 oaks in the Kassel, each linked to a block of basalt rock. Thus the sculptures would evolve and the relationship between organic and inorganic material continually alter. His friends called him 'The Green Man'.

Another 'green artist', John Craxton, is aware of a more sinister element in the metamorphosis of trees into men. His work is influenced by Samuel Palmer and investigates the mystic connection between Man and Nature. Artistically his tree figures also have an affinity with those of the earlier painter Arcimboldo. In a television interview John Craxton spoke of the influence of wartime London on his attitude to Nature and hence on his art:

66 Oxfordshire, Bodleian Library, Oxford. The Green Man has a fierce animal like head with sharp teeth and bulging eyes and a small horn in the centre of his brow. The branches that spring from the sides of his mouth have turned into beast heads. Felicity Howlett

> One was driven into seeing the world in a kind of stressful way. The trees became distorted and misformed and in the Winter time they formed great gnarled shapes like fists and gesticulating arms and I found this extraordinary surrealistic way these trees were coming over the walls at one as one was walking underneath to grab one and menace one.

In the same interview, commenting on his influence by Arcimboldo, Craxton talked of the 'transforming' and 'enigmatic metamorphic figures' and his fascination with the fact that 'Nature's not absolutely pinpointed and can change and turn'.

In the late twentieth century, English writers such as the poets Charles Causley and Andrew Motion, and the novelist Sir Kingsley Amis, also did not see the Green Man entirely in benign terms. In his fine poem 'Green Man in the Garden', Charles Causley injects a slightly sinister note, an ambivalent personification:

Green Man in the Garden,
Staring from the tree,
Why do you look so long and hard,
Through the pane at me?
Your eyes are dark as holly,
Of sycamore your horns,
Your bones are made of elder branch,
Your teeth are made of thorns.
Your hat is made of ivy leaves,
Of bark your dancing shoes.
And evergreen and green and green,
Your jacket and shirt and trews.

'Leave your house and leave your land
And throw away the key,
And never look behind', he creaked
'And come and live with me'.
I bolted up the window,
I bolted up the door.
I drew the blind that I should find
The Green Man nevermore.
But when I softly turned the stair
As I went up to bed,
I saw the Green Man standing there
'Sleep well my friend', he said.

(Charles Causley — *Collected Poems*)

This poem beautifully captures the interface, the tension between nature and civilisation, the man inside his house staring through the blind with curiosity, and a kind of longing for the untamed nature outside, which is still a part of himself. This natural world is personified by the Green Man, who is composed of its parts. But although nature is seen by the environmentalists as entirely on the side of enlightened man against the forces of industrialisation, commercialisation and politics which threaten the habitat of the planet, early man had a more ambivalent attitude towards the forces of nature which could destroy him; the development of enclosed communities and 'civilisation' was to some extent a protection against the excesses of the natural world.

But of course it is fatal to disregard the forces of nature, either on the planet generally or within ourselves. We cannot shut it out and when the figure in the poem tries to do this he finds that nature, in the form of the

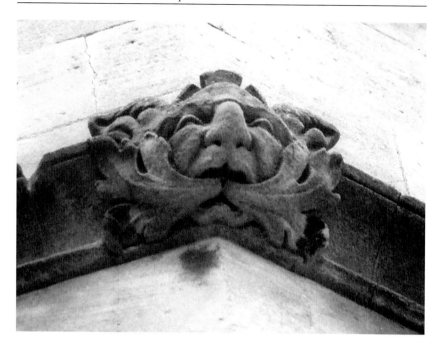

67 *Oxfordshire, Merton College, Oxford. Stone head inside quad. The broad faced Green Man boss that hides the cornice has animal ears and lion lips from which issue veined leaves.* Felicity Howlett

Green Man, has entered his house unexpectedly, just as the Green Knight enters King Arthur's hall in *Sir Gawain and the Green Knight*. Probably only those of us especially interested in both the possible medieval and modern connotations of the Green Man can appreciate how clever and illuminating Charles Causley's poem is.

Andrew Motion's poem on the subject of the Green Man is called 'The Riddle'. As in Charles Causley's poem, the Green Man actually speaks — in fact in Andrew Motion's poem he delivers a soliloquy. His component parts are of oak, rather than the variety of trees that constitute his makeup in Charles Causley's poem. Andrew Motion's Green Man has an affinity with the church and cathedral carvings through having, in the Green Man's words 'particular leaves come rioting out of my mouth'.

In Sir Kingsley Amis's novel *The Green Man*, published in 1969, the hero, Maurice Allington, is the alcoholic landlord of an ancient pub called 'The Green Man' who seems to have visions. In this exciting novel it turns out that the pub owes its name to traditions of a menacing Green Man monster, made of twigs and branches, which is re-animated by a seventeenth-century wizard, a clergyman known as Dr Thomas Underhill. Dr Underhill has defied death

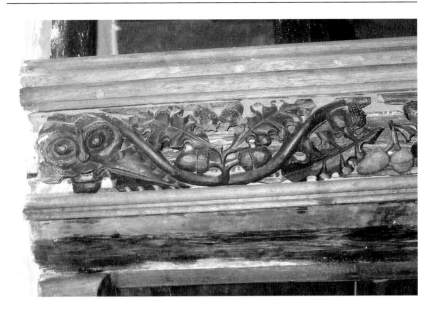

68 Powys, Pennant Mellangel Church, near Llangynog. This Green Man with his huge bulging eyes and emaciated skull is so stylised that it ceases to be human. The gaping mouth exudes thick branched oak leaves and acorns that form part of the frieze decoration of a fifteenth-century wooden screen. Peter Kemmis Betty

and makes contact with Maurice, and the re-animated Green Man monster attacks Maurice's daughter.

Sir Kingsley Amis's Green Man is far-removed from the cosy protective Green Man of the environmentalists, but it is linked into a specifically Christian world because Underhill is a Satanist and Christ makes a personal visit and appeal to Maurice in the novel, ordering him to destroy Underhill. The weapon Maurice uses to destroy both wizard and Green Man is exorcism.

Amis's *The Green Man* was expertly dramatised on BBC television in 1991, with the dramatic script written by Malcolm Bradbury, and starring Albert Finney as Maurice Allingham. Although excellently produced and acted as a whole, the visual portrayal of the Green Man/tree monster did not achieve the awesome effect that the author was aiming for. The film *Where the Heart is* (1990), directed by John Boorman, is about a 'rebirth' and features a character completely covered in green paint.

In the medium of opera, Sir Harrison Birtwistle has been especially interested in the subject of the Green Man, drawn to the subject by his interest in archetypal characters to express his musical ideas. His dramatic pastoral *Down by the Greenwood Side* was commissioned by the Brighton

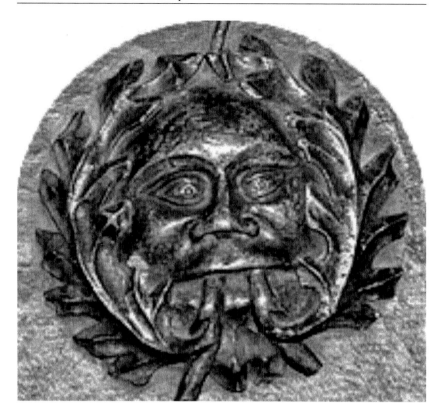

69 Shropshire, St Laurence, Ludlow. Sixteenth-century misericord with the Green Men as 'supporters'. Felicity Howlett

Festival in 1969 and televised by London Weekend Television in 1972. It dramatises a form of Mummers Play (see chapter 5) in which the traditional Doctor (Jack Finney) wears a green costume and revitalises the dead combatant. The treatment is highly ritualistic and colourfully symbolic, and the music is eerie and unsettling, yet with elements of the comforting pastoral.

Sir Harrison Birtwistle's later opera *Gawain*, which had its premiere at the Royal Opera House Covent Garden, is a dramatisation of *Sir Gawain and the Green Knight* (see chapter 5). We saw a second production of this opera at Covent Garden in 1994. The music was appropriately sinister, ritualistic and richly textured, and the sets were stunning, ingenious and symbolic. A wheel device was used for the circular movement of figures symbolising the passing of the seasons and the hunting of deer, boar and fox, with the interior scenes being used in tandem for the arming of Gawain and the bedroom temptation scenes. In the composition of this opera, Birtwistle was

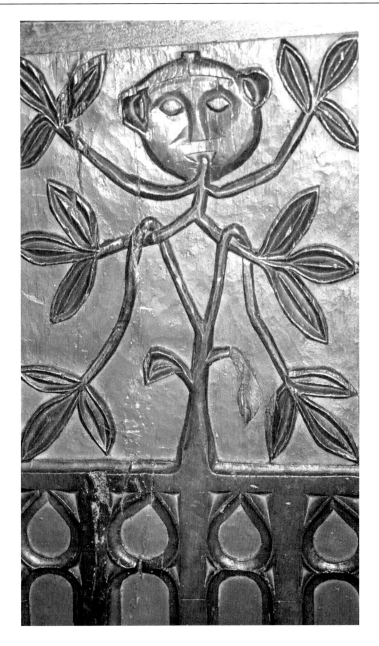

70 *Somerset, St Mary's Church, Bishops Lydeard. This fifteenth-century bench end has a Green Man whose disgorged foliage has become a body, with arms and legs, all of which are held earthwards by a tree in leaf.* Felicity Howlett

particularly influenced by the carvings of Green Men in Southwell Minster (see the gazetteer). Interviewed on *Omnibus*, Sir Harrison Birtwistle said:

> I was intrigued by the mystery of what the Green Man is. For me he became something of a personal God . . . The Gawain poem is about the outside world coming in and that's what drew me to it. I think there is a lot of speculation about whether the Green Knight is the Green Man, but I suppose the person who wrote it when he did was not oblivious of the fact of his existence.

Birtwistle's music for this opera was also turned into an orchestral piece, 'Gawain's Journey', which had its premiere in 1991 and has been recorded.

The librettist, David Harsent, made some radical changes in interpretation of the medieval text, for example showing a Gawain and a court confident that the Green Knight will be killed by the axe blow (whereas in the text they suspect a supernatural trick), and he shows the knights of Arthur's court shunning the returning Gawain. We feel this to be a complete misinterpretation of the poem's meaning and indeed of the nature of medieval romance where the questing knight returns home for sympathy and comfort after his adventures, not rejection. In the poem Arthur's knights are not corrupt, overconfident and sinister, but young, unthinking and slightly tipsy with New Year celebrations. However, their comitatus is powerfully invoked at the beginning, where they try to prevent Arthur from endangering his life in a tryst with a supernatural being, in the second Fitt where the knights try to dissuade Gawain from his hazardous journey, and particularly at the end where knights agree to wear green sashes in moral support of their fellow knight, Gawain.

Morgan is given a much stronger role in the opera than in the poem, David Harsent explaining in an interview in the programme for the 1994 opera (which has excellent background information on the poem and on the Green Man) that he wants 'to provide the audience at once with the notion of a conflict . . . To show that Morgan is a threat to Arthur and the rest' — so he has her (and Bercilak's wife) present on stage from the outset, but invisible to the knights. One of David Harsent's first poems, 'Legendry' from his collection *A Violent Country* features the finding 'Deep in the wood . . . The mythical child' who was 'as green as ice'. He also says in the interview:

> The Green Knight might have been written by the Gawain poet with the Green Man in mind . . . But he's not regeneration myth incarnate . . . He takes what he needs from the Green Man; coming at the turn of the year, being decapitated but surviving and so on. But more than that, he's an aspect of Morgan's magic; he's

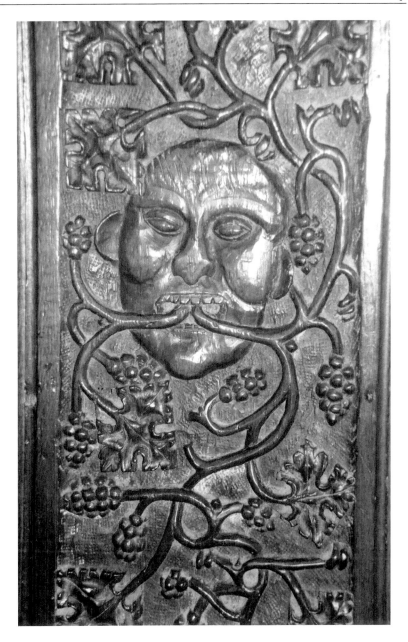

71 *Somerset, Church of The Holy Ghost, Crowcombe. Sixteenth-century bench end with a Green Man disgorging fruiting and leafy branches.* Felicity Howlett

also a remarkably sophisticated device of narrative progression and of retribution, immensely versatile.

Does this considerable creative cultural outburst of activity on the Green Man theme (not to mention the recent academic interest in the study of both *Sir Gawain and the Green Knight* and the Robin Hood legend) reflect William Anderson's suggestion of the awakening of the sleeping archetype, of the return of the Green Man? Or does it reflect a new aspect to our culture, which we are trying to ratify by associating with traditional stories, values and customs?

10 In my end is my beginning

What conclusions can one come to about the Green Man after the sifting of all this evidence? It is a male symbol in some way connected with the resurrection of the life force, found in ecclesiastical stone and wooden carvings in Britain quite rarely in the late twelfth century and then with increasing frequency in the thirteenth, fourteenth and fifteenth centuries after which it declines with the collapse of the Roman Catholic faith in the sixteenth century. The continued use of the symbol as a literary device by Protestants on the Continent is highly significant, because there it appears to relate to the 'new' order and religious freedom.

Underlying the concept of the Green Man lies the age-old relationship of life and death to the passing of the seasons. The seasonal year is a life span in natural terms which can symbolically equate to the whole life-span and death of a human being (the same comparison can be made symbolically with a single day, with night equating to death and the morning with resurrection; the mass in the Catholic faith symbolises the daily death and resurrection of Christ). Thus the death and resurrection of a human being can be shown symbolically by the disgorging of deciduous vegetation, corresponding to the annual cycle of death and rebirth. The poem *Sir Gawain and the Green Knight* encompasses a whole year and has passages defining the passing of the seasons. And, more recently, John Piper's many paintings of the Green Man show him at different seasons of the year. The Green Man ecclesiastical carvings also depict different seasons, sometimes simultaneously in the same carving, though Autumnal iconography and brown colouring is dominant. Possibly linked to the Autumnal season is the fact that the Green Man is often carved as a mature man, slightly above middle age, but still vigorous.

William Anderson's suggestion that the ecclesiastical carvings and the folk customs and traditions which we have explored, are linked through being responses to a common archetypal driving force, is fascinating, but could lead to a diffuse rather than precise definition. Which season is relevant – May, Autumn or Midwinter? Or is the common ground simply regeneration of the force of Nature? The primitive superstitions of the folk enacted through their seasonal customs and sympathetic magic practices engaged with the same life-force which more sophisticated religions such as Christianity also sought to harness.

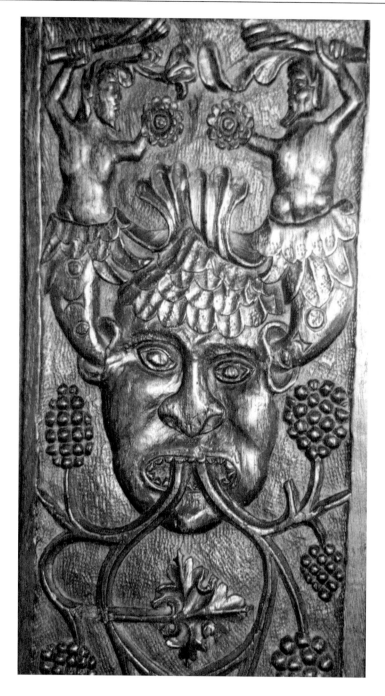

72 *Somerset, Church of the Holy Ghost, Crowcombe. Sixteenth-century bench end. The Green Man has 'wild mermen' exiting from his ears and fighting with clubs and shields.* Felicity Howlett

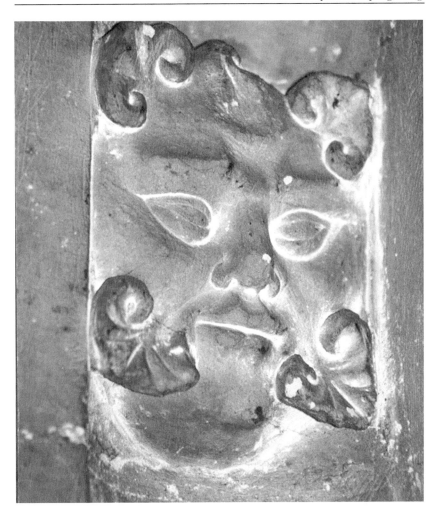

73 Suffolk, St Peter & St Paul, Clare. Highly stylised Green Man is inset into the porch decoration of the south door. Foliage grows directly from within its face and the eyes are distinctly leaf-shaped. Felicity Howlett

Undoubtedly the Green Man has taken a prominent cultural role in recent years in Britain — perhaps as William Anderson and Susan Clifford suggest in response to the ecological crisis. Again the symbol is protean. The Green Men created by Sir Kingsley Amis, Charles Causley, Andrew Motion and Sir Harrison Birtwistle are all distinct and none are so cosy as the ecological Green Giant. Unlucky connotations are fast disappearing for the colour green, and the colour is used as a 'go' signal for traffic lights and crossings and a symbolic signal of hope for environmental organisations.

74 *Sussex, St Mary's Hospital, Chichester.* Geoff Doel

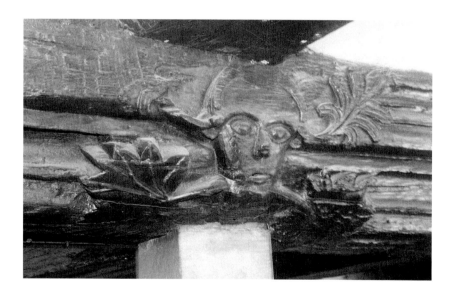

75 *Steyning, Sussex. A rare secular and domestic example of a Green Man, branches sprouting from its cheeks and ears, carved on a roof beam in the post office in the High Street. The building is said to have formerly been an inn.* Geoff Doel

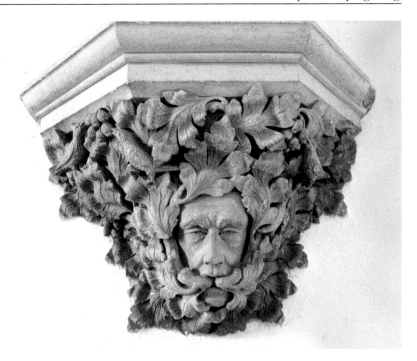

76 Wiltshire, All Saints, Sutton Benger. Naturalistically carved early fourteenth-century Green Man in the south transept with beautifully observed greenery which includes hawthorn, berries and feeding birds. Geoff Doel

Perhaps the most fundamental difference between the medieval and modern concepts of the Green Man is that for medieval man he signified personal spiritual resurrection, whilst for modern man he symbolises our attempt to save the planet from our own excesses. Medieval man sought a heaven for himself; we seek the survival of an earthly home for our children to inhabit.

Gazetteer of Green Men in Britain

Abbreviations: c = century; GM = Green Man

Avon
BRISTOL – St. Mary the Virgin, Redcliffe – c14 corbel and roof boss, and rare c14 GM in stained glass in reconstructed window along with image of the Virgin. Several GM carvings in St John's Chapel. Foliate skull at base of Sandford and Challoner memorial circa 1747.

Buckinghamshire
AMESBURY – St Mary and St Melor – several foliate heads on wooden bosses, early c16

LANGLEY MARISH – St. Mary – two corbels, one leonine, c15

LECKHAMPSTEAD – St Mary the Virgin – c14 panel on font

Cambridgeshire
CAMBRIDGE – King's College Chapel – two bosses on ceiling of the north chapel and carving on choir screen.

CAMBRIDGE – King's College Gatehouse – three roof bosses, thought to be early c19

CAMBRIDGE – Queens College -c19 GM on balcony

CAMBRIDGE – Museum of Archaeology – several c19 GM of varying styles on gatehouse

ELY CATHEDRAL – several GM on roof bosses and stone carvings in Lady Chapel, dated 1360, woodcarvings in choir, and two stone carvings at base of pillar in north transept of choir. At least four foliate heads in choir. Chantry Chapel of Bishop West (1533) has several on ceiling. The octagon has one GM, with a green lion on octagon arch. Several other green lions.

GREAT SHELFORD – St. Mary – c15 boss inside porch

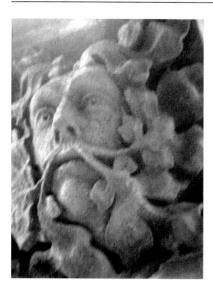

59 Wiltshire, All Saints, Sutton Benger. Early fourteenth-century exterior corbel, finely and naturalistically carved. Geoff Doel

PETERBOROUGH CATHEDRAL – external carvings on frieze, internal GM on bosses in porch and nave roof

Cardiff
LLANDAFF Cathedral – capital

Cheshire
ASTBURY – St Mary – c15 roof boss

CHESTER CATHEDRAL – misericord of 1390 of GM with crown of oak leaves, roof bosses, corbels and foliate bench ends

NANTWICH – St Mary – c14 stained glass & sandstone head.

Cornwall
LOSTWITHIEL – St. Bartholomew – an 'exotic' GM on font, c14 or c15

ST LEVAN'S – wooden boss on restored roof of south aisle; might be medieval but could be part of the restoration. The churchyard has the famous cleft stone with St Levan & Merlin folklore and below the church on the path to the attractive cove is St Levan's ruined chapel & holy well; so the remote site is worth visiting.

Cumbria

ABBEY TOWN – St Mary – stone carving to the left of Norman doorway. Head disgorging vegetation from mouth. The church was built on the nave of Holme Cultram Abbey (founded 1150) and was restored in 1883.

BOLTON GATE – All Saints – corbel, above the west window, dated to about 1450.

BROUGHAM – St Wilfred's Chapel – oaken arm rests said by Pevsner to be c15 French in origin. The Chapel interior was refurbished in 1830s and 1840s with woodwork brought from the Continent. .

CARLISLE CATHEDRAL – several pillar capitals in nave aisles, including GM & green lion in south aisle and GM at west end of north aisle.

CARTMELL PRIORY – several misericords of c15, including a crowned foliate tricephalos

CROSBY GARRETT – St. Andrew – capitals of GM & green animal of late c12/ early c13.

GOSFORTH – St. Mary – 6 stone capitals above Norman pillars repositioned in c14 to support the widened chancel arch.

IRTHINGTON – St Kentigern – capital

KIRKBAMPTON – St Peter -capital claimed as late c12

LOWTHER – St Michael – capital about 1175 – leaves issuing from mouth and cap of leaves and twigs. Plus a couple of capitals of animals disgorging vegetation.

TORPENHOW – St Michael – Jacobean ceiling thought to come from the hall of a London Livery Company. Several heads associated with oak leaves.

Derbyshire

BAKEWELL -All Saints, a crowned GM misericord in association with acorns; also a stone carving on the apex of an arch

Devon

BAMPTON – St Michael , Exmoor. Bosses and capital in chancel and carving on c16 pulpit

BARNSTABLE – St Peter & St Mary – c19 capitals

BOVEY TRACEY – St Peter, Paul & Thomas, Dartmoor. c15 roof bosses in aisle and GM in porch.

BRAUNTON – St Brannock – boss in nave

BROADCLYST – St John the Baptist, c16 capital in nave of two GM connected with carving of rope tied into a knot. Plus bosses in aisles and exterior leonine figure

CHAGFORD – St Michael, Dartmoor. Bosses in south aisle of nave and north aisle of chancel.

CHITTLEHAMPTON – St Hieritha – capital

CHULMLEIGH – St Mary Magdalene – several painted bosses, bench end and a green king on a screen

COLEBROOKE – St Andrew – c15 capital in nave and GM on Coryton Memorial

COMBE MARTIN – St Peter ad Vincula – GM on screen dated 1427 and GM capital on north side of nave.

CREDITON – Holy Cross, stone corbel on south wall of nave with vine & grapes. Crediton was the birthplace of St Winfrith (later named Boniface), a prominent missionary in Germany in c8 who cut down the sacred oak of Thor at Geismar. Crediton church is probably on the site of an early monastery founded through his influence.

CULLOMPTON – St Andrew – several bosses in north aisle and two capitals

DODDISCOMSLEIGH – St Michael – capital

DUNCHIDEOCK – St Michael – 4 c15 roof bosses

EAST BUDLEIGH – All Saints – corbel and c16 bench ends.

EAST DOWN – St John the Baptist – several GM on rood screen and especially on spandrels including a Janus GM (ie facing 2 ways)

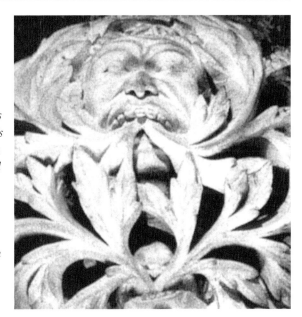

78 Worcestershire, Pershore Abbey. Thirteenth-century stone roof boss. This representation of the Green Man generates immense energy. This is a death-head, with grimacing mouth and bared teeth, peering with dead eyes out of a profusion of encircling vegetation which originates from within its throat.
Felicity Howlett

EXETER CATHEDRAL – There are about 50 prominent carvings either disgorging foliage or in association with profuse greenery (often as headgear) as figures perhaps associated with the May Games; most are c14. 13 corbels in the nave; roof bosses include 2 in the chapter house, 2 in the refectory, 2 on the west front, 5 in the north nave aisle, one in the south nave aisle, 2 in the north transept, 2 in the south transept, one in St. Gabriel's Chapel, one in the ambulatory outside the Lady Chapel, one boss with four heads and another with head disgorging in the Lady Chapel,. 7 in the choir, one in the pulpitum and 2 in the north choir aisle over tomb of Walter Anthony Harvey. Spectacular GM misericord on the south side of the chancel on the Sub Dean's seat with large leafy branches growing like horns out of the head and 4 low level stone heads associated with the screen nearby, one at each end that are difficult of access.

EXETER – Cathedral Deanery, 2 roof bosses in the Lower Hall

FREMINGTON – several capitals

FRITHELSTOCK – St Mary & St Gregory – former Priory church – capital

HIGH BICKINGTON – St Mary – a variety of GM bench ends on nave pews

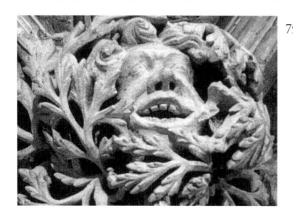

79 *Worcestershire,*
Pershore Abbey.
Thirteenth-century stone
boss. Again the greenery
is depicted as having life
and energy while the head
with its sunken cheeks
and grimacing mouth
may be in its death throes.
Felicity Howlett

ILFRACOMBE – 5 wooden bosses in a line on the barrel-vaulted ceiling of the nave (restored 1960)

KING'S NYMPTON – St James, near the Taw Valley, between Dartmoor and Barnstable.. There is a GM on the Rood Screen (c 1480), disgorging oak leaves from his mouth, with others emanating from the crown of his head. Also six GM on wooden nave bosses disgorging vegetation in association with two bosses of female heads not disgorging vegetation .

MARWOOD – St Michael – capital in nave & GM on c16 screen

MEAVY -St Peter, Dartmoor – roof boss

NORTH BOVEY – St John, Dartmoor, c15 wooden GM roof bosses and c16 bench end

NORTH MOLTON, GM wooden roof boss in south aisle with tongue hanging out.

OTTERY ST MARY – St. Mary, three c14 corbels, one with vegetation from eyes, nostrils and mouth and brightly coloured. And one roof boss in a northern chapel to the aisle which is used as the church shop. The village houses a spectacular traditional tar barrel rolling ceremony on November 5th.

PILTON – St Mary – GM on rood screen and corbel in north aisle with 4 skull like GM heads on arches brackets painted white. A GM festival is held here.

PLYMPTON – St Mary, 2 stone heads with mouth foliage in the porch, and roof corbels outside.

SAMPFORD COURTENAY – St Andrew – on northern edge of Dartmoor. 4 wooden c14/15 roof bosses in choir & nave).

SHEEPSTOR – St Leonard, Dartmoor, foliate skull on gable of south porch

SOUTH MOLTON – St Mary Magdalen, south of Exmoor. One stone carving of a GM and another foliate head at west end of nave. 4 GM in chancel (two of which are on a freeze) and two stone capitals, one with grapes and vine leaves, on chancel pier carving probably late c14 or early c15

SOUTH TAWTON – St. Andrew – on northern edge of Dartmoor. 4 wooden roof bosses with foliage from mouth and nose of late c14 or early c15.

SPREYTON – St. Michael – on the northern edge of Dartmoor. Roof boss in chancel with mouth and eye foliage, c14 or c15.

TIVERTON – St Peter, pillar capital on north side of nave with 4 GM & green animal heads.

UGBOROUGH – St Peter, bosses on roof of north aisle of nave

WASHFIELD – St Mary the Virgin – GM captital in choir; green dragon associated with foliage on beautifully carved rood screen

WIDECOMBE-IN-THE-MOOR – St Pancras, a church in the heart of Dartmoor with several painted GM wooden roof bosses in the north aisle of the chancel. The bright green colourings look recent additions and one of the carvings is naively described as 'Sir Gawain' in a leaflet without any evidence or reason (presumably because of the association of Gawain with the Green Knight).

WOODBURY – St Swithin – south east of Exeter – a c14 capital on the north side of the nave with 4 GM faces.

Dorset

CORFE – stone carving on apex of arch in nave

DORCHESTER – St Peter – restored by a firm employing Thomas Hardy

in c19. Excellent gold-coloured GM wooden roof-boss and stone corbel of a 'green' lion in the north aisle of nave.

EVERSHOT – St Osmund – exterior corbels.

SHERBORNE ABBEY The nave has 115 late medieval stone bosses, 64 of which are of foliage, but only one is a GM. He is bearded, coloured pink and chewing a large brown branch, attached to which are vines and grapes. The Victorians repainted the bosses – the Abbey guide book notes that 'The colour bears little resemblance to the purer colours used on medieval sculpture'. Another GM is to be found amongst the 12 late c14 corbels which support the wall posts of the timber roof of the south transept & is coloured russet and gold.

UPWEY – St Lawrence – 3 stone GM capitals. The village has a sacred well.

WIMBORNE – Minster – boss in the chancel

Dyfed
HAVERFORD WEST – St Mary – wooden roof boss in nave

Essex
COLCHESTER – Castle Museum – wooden carving on a post from a c16 shop in Colchester

Fife
CULROSS ABBEY of St Mary & St Serf
2 large GM connected by tendrils inset on inside of outer door of porch high up

Gloucestershire
BISHOP'S CLEEVE – St Michael & All Angels – c12 capital

ELKSTONE – St. John the Evangelist – 3 GM on tympanum in porch – c14.

GLOUCESTER CATHEDRAL – a number of GM bosses – in the north transept of the north aisle, in the porch and in the cloisters.

NORTHLEACH – St Peter and St Paul, carving in the porch

SHERSTON MAGNA – Holy Cross, two miles south of Westonbirt School and Arboretum, several small GM stone bosses in the vaulting of the porch

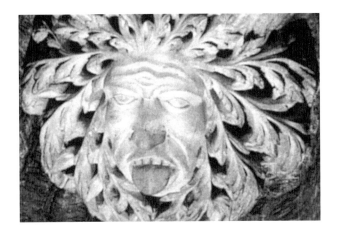

80 Worcestershire, Pershore Abbey. Thirteenth-century stone roof boss. With its rigidly furrowed brow and protruding tongue reminiscent of a hanged man, the hair is a circlet of living leaves growing out of the death head. Felicity Howlett

SOUTH CERNEY – All Hallows – stone head

STANTON – St Michael and All Angels – stone head

TEWKESBURY ABBEY – a number of very fine foliate head roof bosses on vaulting of transepts, choir and chapels and one on a tomb in the south ambulatory.

Gwent
LLANGWM – St. Jerome, c15 corbel – the carving which inspired Lady Raglan to write her celebrated article 'The Green Man in Church Architecture' in 1939

LLANTILIO CROSSENNEY – St Teilo, c14 or c15 carving on wall in north transept

NEWPORT CATHEDRAL – St Woloos, font – mixture of c13 and Victorian

Hampshire
MILFORD – ON -SEA – All Saints, some foliate wooden bosses with heads, thought to be of late date

WINCHESTER CATHEDRAL – A theme of foliage running through the stonework and woodcarvings and many of the tiny heads peeping out of

the woodwork are disgorging vegetation; estimates of the total number of GM vary according to classification, from 30 to 55. As one enters the West entrance there is a magnificent low level GM boss in excellent condition on the vaulting of the narthex, associated with acorns. Nearby, higher up on the roof of the North Aisle are two others. The exotic carvings on the spandrels in the choir include a full-length figure of an armed GM over the choir stalls and two small disgorging GM figures in the angles. The spandrels date from 1307 and are carved by a craftsman from Norwich -there is surviving correspondence about this. 2 misericords in the Choir with green men as flankers, a pair leaf-masks and a contrasted smiling face with a face putting out a tongue; the motifs of this latter has been copied onto a nearby Jacobean bench end head. 2 GM in the Thomas Langton Chapel, 5 on memorial to Edward Cols in north transept and a Green Lion boss on the north west corner of Bishop Wykeham's Chantry. 2 bosses on north side of nave, 2 in south aisle & lots of heads peering through the choir at the back of the screen.

WINCHESTER COLLEGE A GM boss on the porch vaulting is convenient for viewing from the street when the door is open and is conveniently low down. 2 misericords and 3 bosses on ceiling of Thorburn's Chantry Chapel (the vaulting of the Chapel was rebuilt using the old bosses).

WINCHESTER – St Cross – foliate head on boss on the vaulting in the north aisle, near the north door – c15.

WINCHESTER – Royal Wessex Hotel
12 modern stained glass GM by John Piper on screen in foyer.

Herefordshire
ABBEYDORE – Dore Abbey – detached capital fragment

BOSBURY – Holy Trinity – two GM in c16 monument to Richard Harford

GARWAY – St Michael GM carving on chancel arch pillar capital. The church dates from c12.

HEREFORD CATHEDRAL – a lintel carving of the c15 with a stretched face, a roof boss with a dragon with mouth foliage in the Lady Chapel, several bosses in the nave aisles, a misericord and several fragments of early sculptures undergoing restoration

HEREFORD – All Saints – c14 or c15 misericord, 'green' lion or cat

KILPECK – St Mary & St David – a church famous for its Norman carvings. GM on the exterior capital of south doorway & another on a c12 window capital

LEOMINSTER – Priory Church of St Peter & St Paul – c12 century capital.

MUCH MARCLE – St. Bartholomew – several capitals on pillars in nave c1230, a boss and a misericord

Hertfordshire
ALDENHAM – St John the Baptist, early c15

HEMEL HEMPSTEAD – St Mary, capital of 1140 – claimed to be the earliest GM carving in Britain.

ST ALBAN'S ABBEY – Grotesque faces in foliage of the spandrels of the rere-arches of the c14 century screen, and wooden and stone bosses

STEVENAGE – St Nicholas – misericord c15.

Huntingdonshire
CASTOR – St. Kyneburga – 3 c12 capitals, one leonine

Kent
BARFRESTON – St Nicholas. Late c12 tympanum of doorway has seated Christ surrounded by foliage enclosing human heads angels & monsters; exterior of east wheel window includes winged animals transforming into vegetation & exterior also features many corbels of grotesque carved heads, some of which are associated with vegetation.

BRABOURNE – capital c12

CANTERBURY CATHEDRAL – Scarcity of disgorging GM inside is puzzling as there is a profusion of foliage decoration in both stone and woodwork and many grotesques in crypt, including an early c12 capital with 4 disgorging beasts; If the beasts are disgorging vegetation they could be the earliest in the country, but the carved emanations are difficult to identify. GM appear in small quantities in the Cathedral in association with tombs. The Black Prince's Chantry (usually closed) in the Crypt has a fine GM ceiling boss. GM boss in the vaulting of the tomb of Simon Meopham, A of C from 1327 – 1333 in St Anselm's Chapel to the south of choir. Next to it are two mutilated bosses, which look as if they were GM which have

been deliberately destroyed. The tomb of Simon Sudbury. (A of C from 1375–1381) in the south choir has a profusion of carved foliage on the canopy associated with many small heads.

The Cloisters have a splendid profusion of bosses, particularly on the south side where there are 12 GM of diverse patterns, 2 with protruding tongues. All are painted green, possibly in a restoration by Professor Tristram..

CHARING – St Peter and St Paul, 3 bench ends – 2 of dark grained wood still in situ, one humanoid, one feline, & a light-grained bench end of a Robin Hood or forester's head dated 1598 formerly on display (not visible on last visit)

CRANBROOK – St Dunstan – 14th century porch with a central vaulting boss of a stone head amongst foliage. The chancel has 4 wooden bosses of about the year 1300, 3 of GM and the other of a bird amidst foliage

EYNSFORD – St Martin – head corbel to roof of north aisle

FAVERSHAM – St Mary of Charity – misericord

HIGHAM – St Mary – several wooden GM on c14 door.

LENHAM – St Mary – corbel in nave

MINSTER – St Mary – misericord of early c15.

PATRIXBOURNE – St Mary – c12/c13 capital over door.

PENSHURST – St John the Baptist – large c14 corbel in the Sidney Chapel

PENSHURST PLACE – GM boss (1310) in porch to Great Hall and another above stairs to the Solar.

ROCHESTER CATHEDRAL – Late c12 GM frieze on the West Doorway. Several foliate heads in quire aisles and transepts. 4 large bosses under the tower which may be c19 century copies from medieval models (one copied from a head in the north transept). Modern bosses in Early English style in choir (the eastern one may be medieval). Group coloured green on wall. 3 GM among leaves on the spandrels of the canopy above the tomb of Bishop Hamo de Hethe (1352) in the north choir aisle and 3 in the spandrels below (2 with protruding tongues); plus one GM roof boss nearly overhead of the

tomb. Rochester has a Jack in the Green festival over the early May Bank Holiday weekend – see the Jack during the Monday afternoon procession

ST NICHOLAS AT WADE – St Nicholas – several late c12 capitals with heads on the corners disgorging vegetation on the arches of the south arcade of the nave.

SANDWICH – St Clements – c16 choir stall

TONBRIDGE – St Peter & St Paul – Wooden carving of a GM head believed to be c14 was discovered during repairs to roof of the north aisle in 1938 and recently reset in what is thought to be its original position looking down on what was formerly the site of the altar of the side Chapel of St Nicholas. The head is known locally as 'the silent watcher'.

TONBRIDGE – Public School – There are 6 Edwardian sandstone carved stone heads of GM on the arch supports of the cloister style roofed walkway next to the Chapel, which leads through to the playing fields from the courtyard. They are traditional in style, four being human of varying types and two feline.

WINGHAM – St Mary the Virgin – early c14 misericord.

WYE – St Gregory & St Martin – Exterior GM on string course.

Lancashire
MANCHESTER CATHEDRAL – capitals in the porches, those of the north porch being c15 and those on the south porch late Victorian. Also capitals in the nave and stone heads on the tower.

WHALLEY – St. Mary and All Saints – two gc15 misericords (one with tricephalos) and c15 carving on canopy in choir stall.

Leicestershire
ASHBY FOLVILLE – St Mary – a variety of wooden GM bosses in the nave

CROXTON KERRIAL – St Botolph and St John the Baptist, bench end in nave

HALLATON – St Michael – corbels in the north aisle and roof bosses in the south aisle

HARSTON – St Michael and All the Angels – Victorian stone roof corbels in nave

LEICESTER CATHEDRAL- stone head support to the roof beams in the south aisle. There has been considerable Victorian restoration so it is uncertain whether the head is medieval, restored by the Victorians or Victorian.

SPROXTON – St Bartholomew – stone corbel, obscured by the organ, in the north aisle

THORPE ARNOLD – St Mary the Virgin, stone head boss under the eaves of the nave

Lincolnshire

BOSTON – St Botolph – corbels in the nave and several roof bosses

CADNEY – All Saints – c13 corbel in chancel.

CLAYPOLE – St. Peter – early c14 capital

CROWLAND ABBEY – c15 roof boss.

GEDNEY – St Mary Magdalene, foliate head roof bosses

GRANTHAM – St Wulfram – c13 corbel

HARPSWELL – St Chad – memorial of William Harrington, rector, circa 1350,
& on font

LINCOLN CATHEDRAL – Lincoln has one of the largest sets of misericords in the country ninety two in the choir stalls, dated to the late c14th. There are many legendary subjects, Pevsner commenting 'that there is no system in the subjects chosen or their order', but surprisingly does not include the splendid green man in his list -he has acorns coming out of his mouth and there is also a lion with foliage coming out of his mouth. The stone gateway to the choir aisle has an arch with a green man and a dragon. There is also a green man on a choir stall arm rest of the late c14, and on a roof boss in cloisters.

MOULTON – All Saints, the arcades of the nave have stiff-leaf carvings of the late twelfth century (there is evidence for the church in the process of being built in the 1180s) with some heads in the foliage.

NAVENBY – St Peter, the founder's tomb, Easter Sepulchre sedilia and piscina have a profusion of foliate carvings with occasional small figures

PARTNEY – St Nicholas, the Decorated style north piers have small leaf bands in association with small fleurons and heads

SALTFLEETBY ST PETER – St Peter, rebuilt 1877, but much of the interior of the old church re-used. The north arcade has what Pevsner calls 'a horrifying head, mouth wide open, against a motif of upright leaf carvings.'

THORNTON ABBEY – foliate head bosses under the gatehouse – late c14/ early c15.

THURLBY (near Bassingham) – St Germain, Perpendicular style octagonal font has a small figure with outstretched arms turning into a tree

WEST KEAL – St Helen, north arcade of decorated style chancel has impressive capitals with human and animal heads in foliage

London (Greater)
ELTHAM PALACE – GM roof bosses in the Great Hall

KILBURN ABBEY – the fragmentary ruins of this have one GM; date uncertain.

THE TEMPLE CHURCH, Fleet Street. The circular Nave (based on the design of the Church of the Holy Sepulchre in Jerusalem) is c12 and the Chancel c13. The West Doorway was built in 1185, but has been restored following considerable 2nd World War damage. The innermost arch of the exterior doorway features seven consecutive GM.

WESTMINSTER ABBEY – boss in the Chapel of St Mary and misericord in Henry VII's Chapel.

Lothian
EDINBURGH – St Giles Cathedral – a large number of interesting and varied GM, many in clusters on the pillars in nave and choir.

ROSSLYN CHAPEL – constructed between 1446 and 1492 with a massive collection of esoteric and symbolic carvings. There are said to be 96 GM; we found 29 in a fairly rapid survey all stone in the interior, including bosses, corbels, pendants in the retro choir and a stone frieze.

Norfolk

BLAKENEY – St Nicholas – two arm rests on choir stalls

CASLE ACRE PRIORY – GM on west front of NW tower

CAWSTON – St Agnes – roof boss in south transept, bench end and carving on piscina

CLEY NEXT THE SEA – St Margaret – two bench ends in choir stalls

KINGS LYNN – St. Margaret – c14 misericord with a cross eyed GM, a rib corbel. and a c14 arm rest

KINGS LYNN – St Nicholas – stone heads in nave and porch

NORWICH CATHEDRAL – a splendid set of over twenty painted stone roof bosses of GM in the cloister dated to c14 and c15. Two misericords in the choir.

NORWICH – St Ethelbert's Gatehouse, flint archway with 'chequer' design and two c15 GM bosses on vaultings. C19 GM on Railway Station and nearby private house facing river.

NORWICH – St George, Tombland – smiling GM roof boss in porch roof vaulting, c 1490

NORWICH – St Stephen – Misericord

SALHOUSE – All Saints – base of image niche above south porch

SAXTHORPE – St Andrew – two GM on rood screen

SALLE – St Peter and St Paul, 15th century arm rest, exterior north porch carving and three excellent painted GM in upstairs chapel

SHARINGTON – All Saints – 6 c13 corbels and a roof boss

WESTON LONGVILLE – All Saints. c14 sedilia has two GM, one sprouting branches and the other with protruding tongue and branches coming out of the side of his head.

WORSTEAD – St Mary, Wooden boss of foliate monster in the aisle

Northamptonshire
WADENHOE – St. Mary – corbel, c13.

WARMINGTON – St Mary the Blessed Virgin, several wooden bosses (the wooden roof imitates vaulting). One has foliage from the nostrils, another from the eyes.

Northumberland
HEXHAM ABBEY – misericord, and at least three GM capitals.

Nottinghamshire
NEWARK – St Mary Magdalene – stone carvings (capitals and bosses) in nave, aisles and choir and a misericord.

SOUTHWELL MINSTER – tympana in Chapter House late c13, at least seven, with varieties of plants issuing from the mouths, including buttercup, hops, ivy, bryony, maple with fruits and wild apple, cherry or blackthorn. Plus two corbels and a carving with hawthorn above the abacus of a capital and a full-length figure of a monk on c14 misericord.

Orkney
KIRKWALL – St. Magnus' Cathedral in north and south aisle – three stone heads with foliage from mouth, one head with foliage and lizards.

Oxfordshire
ADDERBURY – St. Mary – c19 misericord

BAMPTON – St Mary – capital to doorway in south transept and a misericord.

DORCHESTER ABBEY – c13 capital

IFFLEY – St Mary the Virgin, Norman boss in chancel – Four foliate heads surrounding coiled dragons

OXFORD – Brasenose College – four exterior stone carvings, two with vegetation coming from the eyes

OXFORD – Christchurch Cathedral – several stone bosses with mouth foliage in late c15 choir vaulting and bosses in the cloisters

OXFORD – Christchurch College – stone carvings in quadrangle

OXFORD – Merton College -three stone heads – two inside quad, the other on the street side

OXFORD- Magdalen College – exterior stone carvings facing main street

OXFORD – Pembroke College – several exterior stone heads

OXFORD – St Frideswide – GM dated to 1290, face obliterated

Pembrokeshire
St David – St David's Cathedral – the choir has misericords and bench ends of GM, the cloisters feature c13 bosses and there is a corbel above the doorway at the west entrance to the Cathedral

Powys (Wales)
OLD RADNOR – St Stephen, boss

PENNANT MELLANGEL, near Llangynog – c15 screen

Roxborough (Scotland)
MELROSE – Abbey Museum – c15 roof boss, massive roots or branches protrude from eyes and mouth.

Rutland
OAKHAM – All Saints – capital in the north arcade of the nave and a boss in the north aisle of the choir

Shropshire
LINLEY – St Leonard – c12 century tympanium. Whole figure naked and smiling green man disgorges branches and leaves

LUDLOW – St Laurence – misericord, c16th, of beast with superb cross eyed green men as supporters

Somerset
BICKNOLLER – St George

BISHOPS LYDEARD – St. Mary, between Taunton and the Quantocks, fine collection of c15 bench ends, including several GM

CHEDDAR – St Andrew – roof bosses and bench ends

CONGRESBURY – St Andrew, wooden roof boss

CREWKERNE – St Bartholomew – late c15 corbel

CROWCOMBE – The Holy Ghost, between Taunton and the Quantocks, fine collection of c16 bench ends, several with mythological subjects including three GM, one an "exotic" with wild men exiting from ears brandishing clubs.

HALSE – St. James, between Taunton and the Quantocks, a roundel circa 1300.

QUEEN CAMEL – St. Barnabas – fine wooden roof boss at east end of north side of chancel roof, c15. Also two gilded GM with foliage coming from between their eyes, sides of nose and mouth, on each side of the chancel arch.

SHEPTON MALLET – St Peter and St Paul, two wooden bosses on nave wagon roof, both with stems from the mouths and one of them from the eyeballs

SPAXTON – St Margaret, bench end

WELLS CATHEDRAL – c14 foliate heads on roof bosses in the undercroft and chapter house and c13 capitals in the nave.

WELLS – St Cuthbert – porch boss, corbel in north aisle and pulpit carving

WITHYCOMBE – St Nicholas, Picturesque ancient Exmoor church. On north side facing the door is carved a figure of a widow flanked with candlesticks with masks & foliage; date about 1300.

YEOVIL – St John – roof boss of two GM with mouth foliage

Staffordshire
ENVILLE – St Mary – tomb

GNOSALL – St Lawrence – roof bosses & capitals & boss of dragon with foliage

LICHFIELD CATHEDRAL – c14 capital, boss and spandrels in the choir; bosses in north and south transepts and Lady Chapel and two c13 corbels in the West Portal Chapel,.

LONGDON – St James – late c12 capital on doorway

LYME PARK – 2 internal

STAFFORD – St Chad, chancel arcading (c12) & choir stalls

Strathclyde
GLASGOW – St Mungo's Cathedral (Church of Scotland), a number of stone heads and some bosses in the Blackadder Aisle.

Suffolk
BLYTH PRIORY – angle head with mouth foliage

CLARE – St Peter and St Paul – carvings round door and in south porch

MILDENHALL – St. Mary – c15 boss inside porch

Sussex
ALFRISTON – Star Inn – roof beams above door – c17.

BATTLE ABBEY – Gatehouse, built from 1338, has stone GM bosses on the arches.

BOXGROVE PRIORY – small GM carvings and a series of "wild men" in Chantry. The Chantry was built for Thomas, fourth Lord de la Warr and his wife in 1532.. The carvings on the chapel's interior pillars are said to depict themes from French Book of Hours. Also one c13 roof boss with eight heads, alternate heads having stems issuing from mouth

BROADWATER – St Mary, north of Worthing, carving on a bench end

BURY – secular carving in main village street above village stores

CHICHESTER CATHEDRAL – carving above the tomb of Robert Stratford, Bishop of Chichester 1337-1362. Boss in south aisle of choir with six faces with golden leaves coming out of their mouths (possibly by the same stone-mason as a related carving at Boxgrove Priory. Boss in the vaulting of the Bell-Arundel Screen (which divides nave from choir).

CHICHESTER – St Mary's Hospital – The hospital is first recorded in c13 as a community of brethren and sisters under a Prior and a Custos (Warden) to care for the sick and the poor who needed a bed for the night. The present

building was probably begun after 1290. The stone chapel, of this date, has a fine collection of misericords, earlier than those in Chichester Cathedral. These include one described by local commentators as a "Jack-in-the-Green", a head with foliage from the bridge of nose, flanked by two smaller carvings of lions. Nearby is a misericord with oak leaves and acorns.

HASTINGS – All Saints – Exterior carvings on tower over south doorway. Probably early c15.

HASTINGS – St Clement – late c14 corbel in nave. Hastings has a Jack in the Green tradition documented in the nineteenth century and revived in late c20 as a GM festival which runs over the early May bank holiday weekend with the Monday being the best day to see the Jack, processing through the Old Town in the morning and at Hastings Castle in the afternoon.

LITTLE HORSTED – St Michael. The doorway has carved spandrels, one with a green man.

MAYFIELD – Archbishop of Canterbury's Hall – the remains of this are now a part of the Convent of the Holy Child Jesus. Pevsner calls the hall "one of the most spectacular medieval halls of England" and it is now used as the convent chapel. The timber roof rests on leaf brackets supported by the busts of figures, one of which is a GM – originally then in a secular location, albeit one connected with the primate of the church.

SHOREHAM (NEW) – St Mary De Haura (of the Harbour), a splendid Norman building. With bosses in the aisles with angle heads with mouth foliage

STEYNING – A splendid rare secular example on a roof beam in the post office in the High Street. Wooden, with branches sprouting from cheek This early timber-framed building was once the Swan Inn.

WINCHELSEA – St Thomas c1310–20, in spandrel above tomb in south chapel – branches issuing from mouth

Warwickshire

ASTON CANTLOW – St. John the Baptist – arm rest

COVENTRY – Holy Trinity – misericord, late c14/ early c15.

STRATFORD UPON AVON – Holy Trinity- eight green men in the vaulting of the transept crossing (four are high up and four are at the bases of the arches). And there is GM misericord and GM at the base of the Gower memorial.

Wiltshire

HOLT – St Katherine – two exterior corbels

LACOCK ABBEY – bosses in cloisters

SALISBURY CATHEDRAL – Foliate head boss under the tower, foliage bosses in cloisters, with several figures & heads and a misericord.

SALISBURY – St Thomas – capitals in the chancel

SUTTON BENGER – All Saints a justly famous early c14 GM with a very realistic human face carved out of oolitic limestone, with associated hawthorn and birds, now in the south transept, but has been relocated there at some stage – Three fine exterior c14 GM heads on the roof.

Worcestershire

BREDON – St Giles – detail of coffin lid in Milton Chapel

HOLT – St Martin, there is an exterior GM on door frame, which could be early, and interior foliate heads on a capital, the font and the c19 pulpit..

PERSHORE ABBEY – GM in c13 choir vaulting and 3 GM roof bosses in the later south transept – one of a 'green King', and another with two GM.

ROCK – St Peter and St Paul – GM carving on one of two faces on a capital on the chancel arch. The church dates from c12.

WORCESTER CATHEDRAL – bosses in the nave, south aisle and cloisters, capitals in the transept and misericords

WORCESTER – St Andrew – roof bosses under the spire

Yorkshire

BEVERLEY – St. Mary – at least six misericords and some c16 foliate head bosses

BEVERLEY MINSTER – two GM in c14 capitals in nave

FOUNTAINS ABBEY – exterior stone carving of amaciated GM at apex of arch

LOVERSALL – St Catherine – misericord, late c14th/ early c15.

PATRINGTON – foliate head roof bosses in east aisle of south transept

RIPON CATHEDRAL – c13 corbels and bosses in nave, and a corbel and a misericord in the chancel

SELBY ABBEY – stone bosses in the north aisle of the quire

SILKESTONE – All Saints – two c15 wooden roof bosses, one oriental

SKIPTON – Holy Trinity – nave bosses dating to c15.

YORK MINSTER – at least eight stone head carvings in the vestibule to the chapter house and many heads associated with foliage in the chapter house.

YORK GUILDHALL – boss in Committee Room One – and two new or restored bosses in main hall

YORK – All Saints – (North Street) – there are two churches of this dedication. Bosses in nave and aisles have GM associations.

Notes

1 The Green Man — invention or recreation?

Our main sources for this discussion are the books by C.J.P. Cave, Kathleen Basford and Wiliam Anderson (see text and bibliography) and the *Omnibus* TV documentary 'The Return of the Green Man', and in particular the contributions of Susan Clifford, Director of *Common Ground* to that programme.

2 Greenness

We have drawn on a wide range of sources, in particular Katharine Briggs' *A Dictionary of Fairies* and Lowry Charles Wimberley's *Folklore in the English and Scottish Popular Ballads*

3 Ecclesiastical carvings

We are particularly indebted to the following sources:
J.C.P. Cave, *Medieval Carvings in Exeter Cathedral*
J.C.P. Cave, *Roof Bosses in medieval England*
M. Cautley., *Norfolk and Suffolk Churches*
M.G. Challis, *Life in Medieval England*
J. Charles Cox, *Bench Ends in English Churches*
A. Garner, *Minor English Wood Sculpture*

4 The Spirit in the Tree

We have drawn on the following sources for this chapter:
Sir James Frazer, *The Golden Bough*
Brian Day, *Chronicle of Folk Customs*
C. Hole, *A Dictionary of British Folk Customs*

5 Sir Gawain and the Green Knight

We have used the editions of *Sir Gawain and the Green Knight* by Tolkein and Davis and John Burrow and provided our own translations. John Burrow's critical work *A Reading of Sir Gawain and the Green Knight* has always been a powerful influence on us and is strongly recommended.

6 The Jack in the Green

Our sources here include Roy Judge's important study *The Jack in the Green: A May Day Custom* and Keith Leeech's very helpful and well-researched booklet on *The Hastings Jack in the Green*.

7 The Man in the Oak

This chapter mostly consists of original research and speculative ideas and our own observations during many visits to the Castleton Garland Day. A number of Castleton participants have provided helpful information, including particularly George Bramhall, a key member of the organising committee for many years.

8 The Burry Man

Again this is based on our own observations of the custom, supplemented by accounts by Christina Hole (*A Dictionary of British Folk Customs*) of the early and analogous accounts and Brian Day (*A Chronicle of Folk Customs*) for the current situation. For scapegoat customs abroad we have quoted Sir James Frazer's *The Golden Bough* and have extensively drawn on Tom and Barbara Brown's revival of the Earl of Rone Ceremony at Combe Martin in Devon and Tom's booklet.

9 The Green Man and the arts

We are particularly indebted to the *Omnibus* television programme 'The Return of the Green Man' and to the contributors and to Charles Causley and MacMillan publishers for the quoting of Charles Causley's fine poem 'Green Man in the Garden'.

Bibliography

Sir Kingsley Amis, *The Green Man* (J. Cape 1969, reprinted by Penguin)

William Anderson & Clive Hicks, *Green Man* (Harper Collins 1990, reprinted by Compass)

William Anderson & Clive Hicks, *The Rise of the Gothic* (Hutchinson 1985)

M.D. Anderson, *Imagery of British Churches* (John Murray 1955)

M.D. Anderson, *Misericords* (Penguin)

Kathleen Basford, *The Green Man* (Boydell 1978)

Sir Harrison Birtwistle & David Harsent, *Gawain* (Royal Opera House, Covent Garden, programme, 1994)

F.Bond, *Misericords* (Henry Frowde, Oxford University Press)

Katharine Briggs, A *Dictionary of Fairies* (Penguin 1977)

Tom Brown, *The Hunting of the Earl of Rone* (Earl of Rone Council 1987)

John Burrow (ed.), *Sir Gawain and the Green Knight* (Penguin 1978)

John Burrow, *A Reading of Sir Gawain and the Green Knight* (Routledge 1965)

Henry Burstow, *Reminiscences of Horsham* (1911)

Charles Causley, *Collected Poems* (MacMillan)

C.J.P. Cave, *Roof Bosses in Medieval Churches* (Cambridge University Press 1948)

M.G. Challis, *Life in Medieval England as portrayed on Church Misericords* (Teamband Ltd 1998)

Geoffrey Chaucer, *The Canterbury Tales* (ed F.N. Robinson; OUP 1966)

J.C. Cooper, *An Illustrated Encyclopaedia of Traditional Symbols* (Thames & Hudson 1978)

Crockford's Clerical Dictionary 2000/2001 (Church House Publications)

J.G. Davies, *A Dictionary of Liturgy and Worship* (SCM 1972)

Brian Day, *A Chronicle of Celtic Folk Customs* (Hamlyn 2000)

Brian Day, *A Chronicle of Folk Customs* (Hamlyn 1998)

Charles Dickens, *Sketches by Boz* (Mandarin 1991, originally published 1839)

Fran & Geoff Doel, *Robin Hood — Outlaw or Greenwod Myth* (Tempus 2000)

Geoff & Fran Doel & Tony Deane, *Spring & Summer Customs in Sussex, Kent & Surrey* (Meresborough 1995)

Aemonn Duffy, *The Stripping of the Altars* (Yale University Press 1992)

Sir James Frazer, *The Golden Bough* (abridged edition, 1923)

Ed Jeffrey Gantz, *Early Irish Myths and Sagas* (Penguin 1981)

J.H.P. Gibb, *Fan Vaults and Medieval Sculpture of Sherborne Abbey* (Friends of Sherborne Abbey)

Miranda Green, *Dictionary of Celtic Myth and Legend* (Thames and Hudson 1992)

C. Grossinger, *The World Upside Down: English Misericords* (Harvey Miller 1997)

Thirlie Grundy, *The Green Man in Cumbria* (Thumbprint 2000)

Mike Harding, *A Little Book of the Green Man* (Aurum Press)

Jeremy Harte, *The Green Man* (Pitkin 2001)

R. Hayman, *Church Misericords and Bench Ends* (Shire Publications 1989)

Clive Hicks, *The Green Man — A Field Guide* (Compass 2000)

Christina Hole, *A Dictionary of British Folk Customs* (Paladin 1978)

William Hone, *Every-Day Book* (1825)

Ronald Hutton, *Stations of the Sun* (Oxford University Press 1996)

Roy Judge, *The Jack in the Green: A May Day Custom* (Cambridge D.S. Brewer 1979)

Thomas Keightley, *The Fairy Mythology, Illustrative of the Romance and Superstition of Various Countries* (London 1850)

Charles Kightly, *The Customs & Ceremonies of Britain* (Thames & Hudson 1986)

Francis Kilvert, *Kilvert's Diary 1870-1879* (ed. William Plomer, Penguin 1977)

D. & H. Kraus, *The Hidden World of Misericords* (Brazilier, New York 1975)

Keith Leech, *The Hastings Jack in the Green* (South East Arts)

Sir Thomas Malory, *Le Morte Darthur — The Winchester Manuscript* (edited by Helen Cooper, Oxford University Press 1998)

Julian Munby, *St Mary's Hospital, Chichester, a Short History and Guide* (Trustees of St Mary's Hospital 1987)

Trefor Owen, *Whatever Happened to Welsh Folk Customs?* (Folklore Society 1985)

Nikolaus Pevsner, *The Buildings of England* (Penguin series 1999)

E.K. Prideaux & G.R. Holt, *Bosses and Corbels of Exeter Cathedral* (1910)

Lady Raglan, *The Green Man in Church Architecture* (article in Folklore vol. L 1939) p45

G.L. Remnant *A Catalogue of Misericords in Great Britain* (Clarendon Press 1969)

D.W. Robertson, 'Why the Devil Wears Green' (in *Modern Language Notes*, Nov 1954)

Frederick Sawyer, *Sussex Folklore and Customs Connected With the Seasons* (Sussex Archaeological Collection 1883)

Reginald Scott, *Discoverie of Witchcraft* (Brome, London 1584)

Sir Walter Scott, *Minstrelsy of the Scottish Border* (1802)

A.C. Seward, *The Foliage, Flowers & Fruit of Southwell Chapter House* (Proceedings of the Cambridge Antiquarian Society vol 35, pp1-32)

Cecil Sharp, *The Sword Dances of Northern England* (Novello Adolphe Smith, Street Life in London 1913)

J.C.D. Smith, *A Guide to Church Woodcarvings* (David and Charles)

John Spiers, 'Sir Gawain and the Green Knight' (article in *Scrutiny*)

Joseph Strutt, *Sports and Pastimes of the People of England* (1801)

Phillip Stubbes, *Anatomie of Abuses* (1583)

Ruth Tongue, *Forgotten Folk-tales of the English Counties* (Routledge and Kegan Paul 1970)

Thomas Trowsdale, 'Garland Day in West Kent' (*The Antiqury*, June 1880)

Jacobus de Voragine, *The Golden Legend* (Princeton University Press 1995)

Lowry Charles Wimberly, *Folklore in the English and Scottish Ballads* (Dover 1965, original edition University of Chicago Press 1928)

Index